Wild Babies

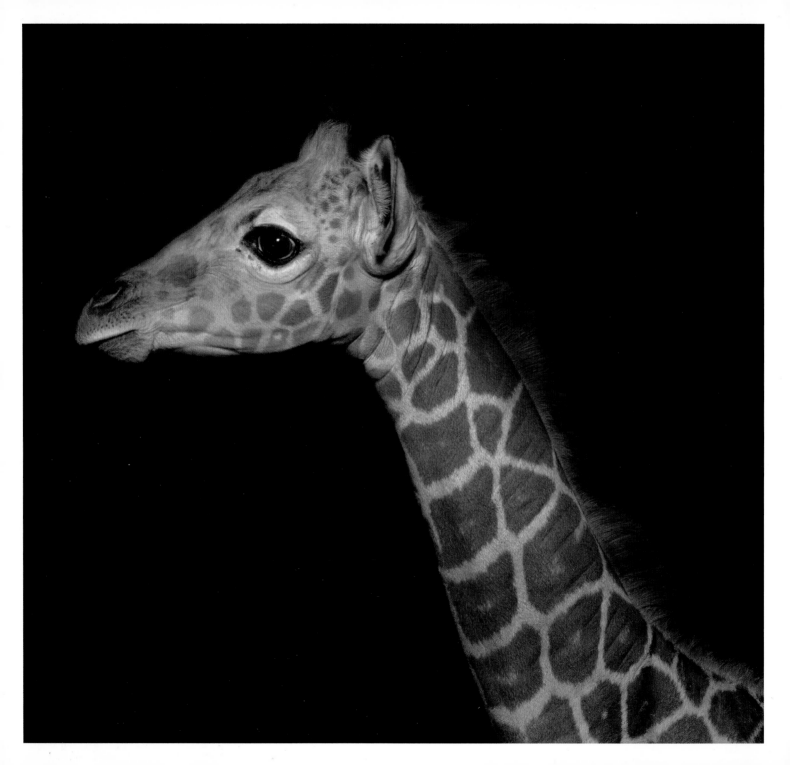

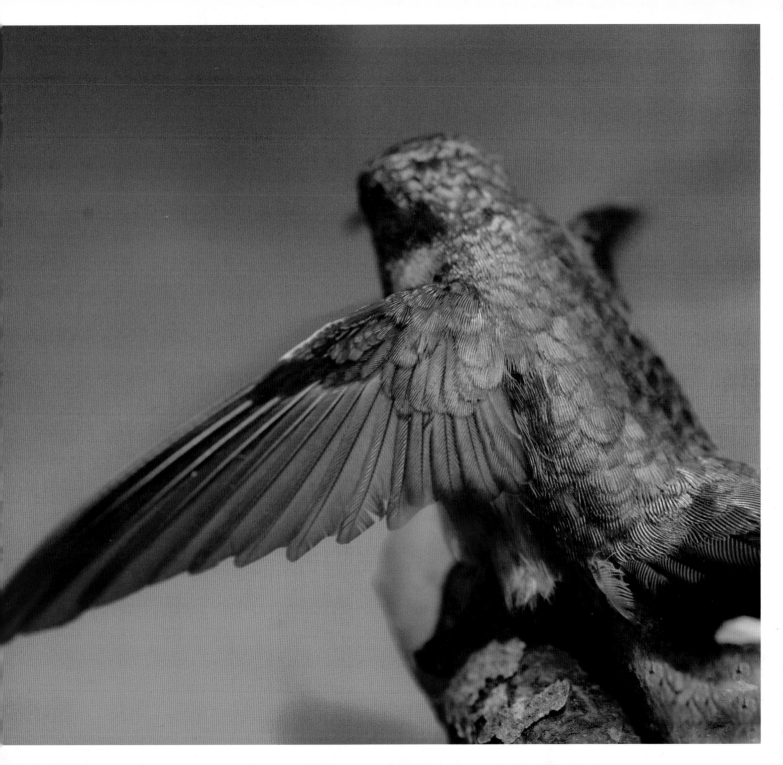

ZEBRA

Thirteen days old

Zebras are members of the horse family, and like their equine relatives, can run at a speed of 35 miles (56 kilometers) per hour or more. A newborn zebra foal is able to run within one hour of being born, which is essential because it needs to be able to move with the herd as soon as possible. A female zebra can give birth to one foal every twelve months and will nurse the foal for one year, until maturity. Foals learn to recognize their mother's unique stripe pattern immediately as they must be able to identify her amidst the herd.

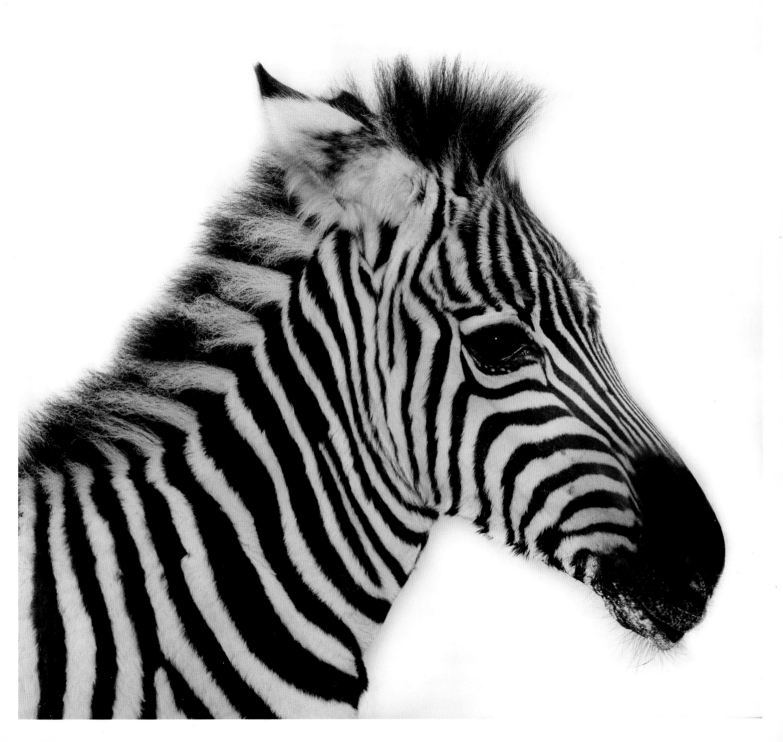

GIRAFFE

Five weeks old

A mother giraffe gives birth standing up, usually after
a fifteen-month gestation period. The baby giraffe, or
calf, is about 6 feet (1.8 meters) tall when born, often
weighing up to 200 pounds (91 kilograms). Calves learn
to walk within hours of being born, to avoid becoming
prey to other mammals like lions and hyenas.

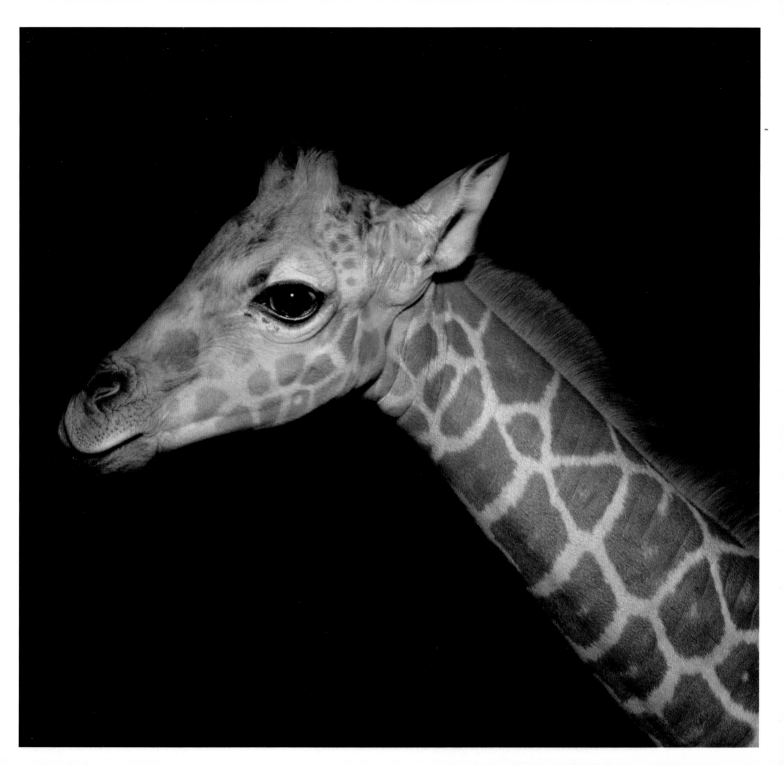

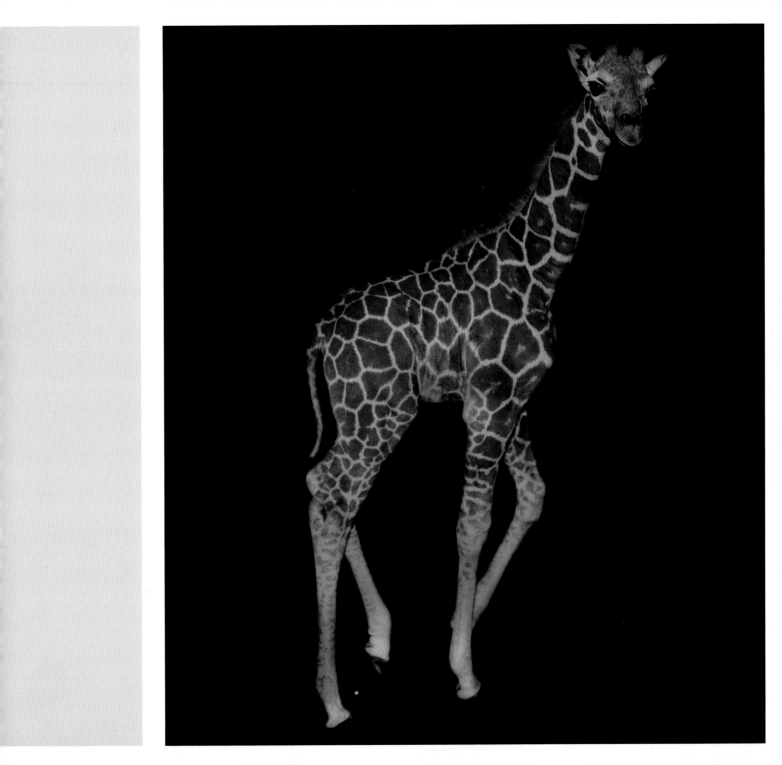

ACKNOWLEDGMENTS

A immense heartfelt thank you to all of the caretakers who gave me rare and trusted access to their baby animals for over two years: Arianna Mouradjian, Kristen Fletcher, and the Wildlife Rehabilitators Association of Rhode Island; Tim Cornwall, Betsey Brewer, and Southwick's Zoo; Lindsey Audunson and Buttonwood Park Zoo; Brenda Young and Capron Park Zoo; and Nancy Sackson, Laura Sherr, Yvette Koth, and all of the amazing staff and volunteers at The Marine Mammal Center.

To my family and to Joan: all my love.

Thank you to my editors, Bridget Watson Payne and Rachel Hiles, for much needed guidance throughout this project and to everyone at Chronicle Books for helping to make it a reality.

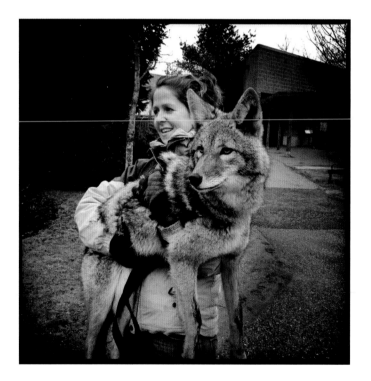

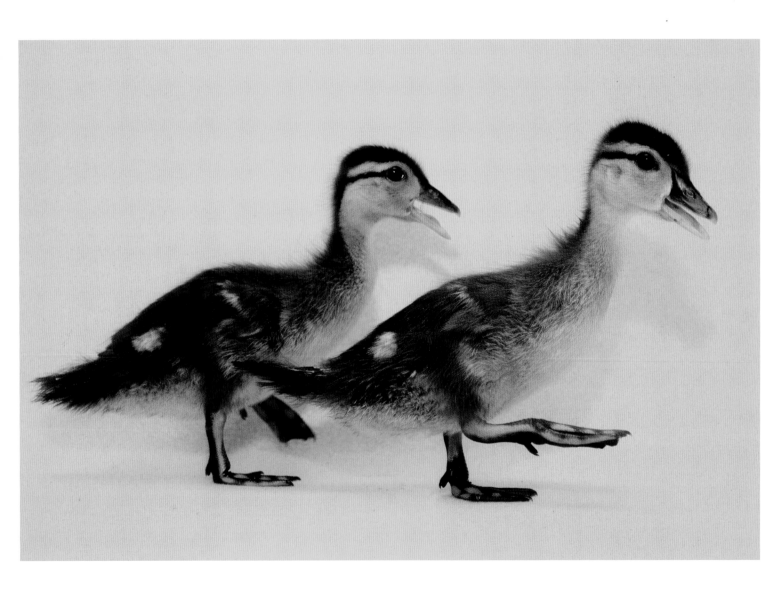

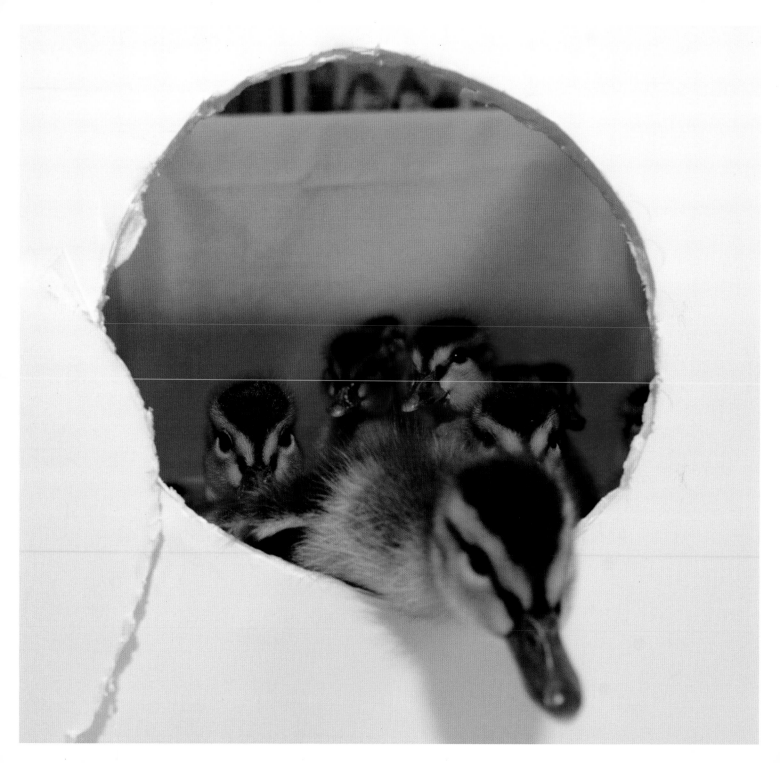

WILDLIFE REHABILITATION RESOURCES

Depending on their location and the prevalence of options for stressed wildlife, wildlife clinics often receive anywhere from two dozen to two hundred baby animals every day in the spring and summer months. Many of these wildlife rehabilitation clinics are privately funded and operate without any state support. Donations from the public, corporate donations, and grants make up a clinic's shoestring budget, which is usually almost exhausted by the end of baby season each year.

You can support these clinics by collecting supplies ranging from easily gotten items like paper towels, detergent, and Ziploc bags to blueberries, dog food, and sardines. Most organizations have a wish list on their website or will gladly tell you what they are in need of over the phone. If you are interested in becoming licensed to perform wildlife rehabilitation in your home, they can provide you with information about classes and procedures.

Generally, the best way to help wildlife is simply to let them be, but in those cases when an animal truly needs help, a quick online search will lead you to local resources like wildlife clinics, individual rehabilitators, or twenty-four-hour veterinarians. If you're interested in learning more about wildlife rehabilitation, here are some resources with more information:

International Wildlife Rehabilitation Council
www.theiwrc.org

National Wildlife Rehabilitators Association
www.nwrawildlife.org

State By State Listings Of Wildlife Rehabilitation Resources:

The Humane Society of the United States
www.humanesociety.org/animals/resources/tips/find-a-wildlife-rehabilitator.html

The Wildlife Rehabilitation Information Directory
www.wildliferehabinfo.org

Wild Babies

photographs of baby animals from giraffes to hummingbirds

TRAER SCOTT

CHRONICLE BOOKS

SAN FRANCISCO

Library of Congress Cataloging-in-Publication Data:

Names: Scott, Traer. Title: Wild babies : photographs of baby animals from giraffes
to hummingbirds / by Traer Scott.
Description: San Francisco, CA : Chronicle Books LLC, [2016]
Identifiers: LCCN 2015040119 | ISBN 9781452134864
Subjects: LCSH: Wildlife photography. | Animals—Infancy—Pictorial works.
Classification: LCC TR729.W54 S45 2016 | DDC 779/.32—dc23 LC record available at
http://lccn.loc.gov/2015040119

Manufactured in China

Design by John Parise

10 9 8 7 6 5 4 3 2 1

Chronicle Books LLC
680 Second Street
San Francisco, CA 94107
www.chroniclebooks.com

For my sweet Agatha, who is just a little bit wild.

A FRAGILE TIME
OF LIFE

The animals in this book are cute. There's no denying it. Perhaps you've never thought of a baby opossum or infant weasel as being adorable, but as you turn the pages of this book, you most likely will. Why do we find baby animals of other species so compelling? Why do these images of wild babies make us feel warm and nurturing?

The answer is that we just can't help it. As humans, we are biologically programmed to feel a need to care for our helpless offspring, which necessarily translates to us finding human infants appealing. Studies show that people feel a range of positive emotions when exposed to photos of human babies. They feel gentler and less angry, and are often flooded with a sudden need to protect and nurture the baby they see. This biological instinct is why we are able to withstand the mental and

physical marathon of parenthood, but studies also show that we have the same reaction to baby animals of other species, particularly mammals.

Most baby mammals share many of the same physical characteristics of human babies: large eyes, round faces, small noses, recessed chins, and plump little bodies. Some animals, like elephants and baby chicks that do not conform to the physical "type," still trigger our nurture impulse through their baby-like behaviors: lack of balance, clumsiness, and a physical closeness to Mom. However, the same mouse or opossum or raccoon that we find utterly irresistible in infancy may suddenly seem unappealing or even threatening when the baby-like features give way to adult characteristics and behavior. We may find ourselves afraid of them, repulsed by them, or even feeling aggressive towards them.

I was first introduced to the world of wild animal babies during a friend's late summer wedding. It was the first outing I had been able to manage since having my daughter. We dressed our little infant in her first fancy frock, and spent the evening fretting about her being too cold or too hungry or too tired. A few minutes after the reception began, we decided it was time to leave, and began trudging to our car. Suddenly a friend's young daughter came running toward us, yelling that she had found a baby squirrel. The little squirrel already had fur and was breathing, but it wasn't moving and did not respond to gentle prodding. It had clearly fallen from a very high nest, though there were no visible injuries. Often, mother squirrels will come and retrieve fallen babies within an hour or so, but the little body was ice cold; she had clearly been exposed to the evening air for some time. It seemed apparent that no aid was coming.

Momentarily forgetting that I had a newborn child who needed feeding every three hours, I instinctually took on the role of rescuer, and told the pair that I would take the squirrel home and nurse it. But by the time we drove the short distance to our house, I realized that I had made a horrible mistake. Baby squirrels need constant care and bottle feeding every two hours, not unlike my daughter.

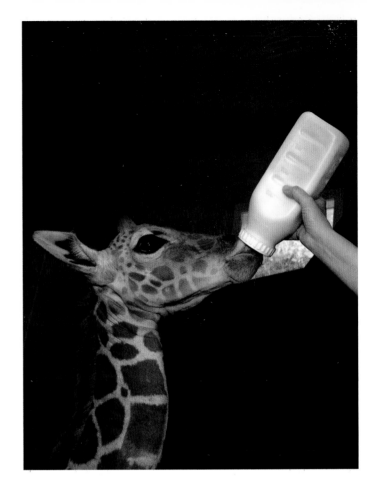

We were already struggling to find balance amidst the immense shift of becoming parents, and could not add another highly dependent creature to the mix.

In doing frantic Internet searches, I found a list of local rehabilitators listed by city and which animals they were licensed to care for. I called the nearest rehabilitator and was delighted that she not only answered the phone at 9 p.m. on a Saturday, but was willing to take in our little squirrel that very night.

I had put a heating pad under the squirrel's box, as it was a chilly night and we suspected that she had been out of the nest for several hours. Her body was warmer to the touch now. Her heart beat faintly, and small breaths caused her tiny body to rise and fall ever so slightly, but she was still not moving.

Leaving my husband to put our daughter to bed, I packed the squirrel up in the car and began to drive to the suburb where the rehabilitator lived. When I arrived at the small house, I opened the box for one last look at the little squirrel. As I carefully slid the cardboard back,

a furry grey head suddenly popped up through the opening, looking overly alert and a bit harried. When I handed the box to the rehabilitator, she picked the little squirrel up and determined that she was female. She said that this squirrel would join the "nursery," apparently comprised of almost a dozen young squirrels of varying ages. After several weeks, she would be released at the base of a big oak to start her life as a neighborhood squirrel.

That Saturday night, a wildlife rehabilitator saved a little life that would have otherwise been lost. I was so impressed with her knowledge and dedication that I began to seek out more information about wildlife rehabilitation and the individuals from all professions and walks of life who dedicate their spare time to helping injured and orphaned wildlife. In my time making this book, I have met lawyers, students, stay-at-home moms, teachers, and construction workers all of whom give a piece of their home and a lot of their time to helping wildlife get back on their feet.

Rehabilitators are more than just caring people; usually they have to be licensed in the state where they live. It is crucial that people who are not licensed do not try to care for injured wildlife. Doing so very often results in death for the animal, and can pose many dangers and health threats to the person and their family. A licensed wildlife rehabilitator will know exactly how to care for a particular species. They will have access to the necessary medication, food, and knowledge to give the baby or adult animal the best chance for survival. They will also be prepared to dedicate the immense amount of time that it often takes to successfully raise a wild baby.

But why does nature need help? Everyone has heard the phrase, "let nature takes its course," an adage that translates to us leaving nature alone to do its thing. The problem is that we are often the problem; humans are sometimes responsible for altering the natural course of things and impeding nature from taking its natural course. Every day, in every corner of our country, indigenous wild animals are imperiled as a result of humans or human

encroachment. Some animals are forced out of their habitats by construction projects, many are hit by cars, babies are often orphaned when their mother is hunted or accidentally killed. In these instances, it could be said that we owe it to nature to help clean up the mess.

Each one of these rescued wild animals must be hand-fed every two hours, twenty-four hours a day, for anywhere from two to thirty days. It's a herculean amount of work, performed by a very small, dedicated group of animal lovers. They are fighting to save the lives of songbirds, raccoons, owls, seabirds, opossums, and even mice. In modern culture we view many of these animals as pests, but they are integral and important parts of our ecosystem, as well as being our native wildlife. Our wildlife should be viewed as a treasure, not a burden or inconvenience.

It isn't just land-dwelling animals that need help. Seals and sea lions are at risk of getting caught in fishing nets, struck by ships, exposed to oil spills, and being harassed by dogs and humans on shore. During a visit to the Marine Mammal Center, a nonprofit organization in Sausalito, California, dedicated to the rescue and rehabilitation of marine mammals, I got a rare opportunity to photograph baby sea lions, elephant seals, and harbor seals. At the time of my visit, the center had over 250 marine mammals in their care, including 36 pacific harbor seals, 75 northern elephant seals, and a whopping 137 sea lions. Most of the animals had been found on the beach malnourished, dehydrated, or injured, by people in the community who then brought them to the center. In 2014, the Marine Mammal Center re-released over 500 healthy animals back into the ocean. Their success can largely be attributed to the small army of highly trained volunteers (over 1,000 people) who take round-the-clock care shifts. Every few hours, teams of welly-clad volunteers administer medicine, fluids, and food as needed to all patients.

At the Marine Mammal Center, I was fortunate enough to enter the pens with volunteers and staff members in order to get intimate access to the animals, but there were several rules that had to be followed at

all times. The most important of those was that we were not allowed to speak while near the animals, or look them in the eye. These rules were in place to protect the animals by helping to keep them wild. Marine mammals can become habituated to people very easily. When this happens, they usually cannot be re-released. Speaking to them, making eye contact, and, particularly, touching them can quickly make them lose their fear of humans, which makes them fall prey to many dangers.

Not looking a seal or sea lion in the eye is easier said than done. They have enormous liquid eyes that instantly melt your heart. They seem so incredibly lovable and helpless. However, although they are not particularly dangerous, marine mammals, particularly elephant seals, do bite. When entering the large pens, I always went in behind a wooden shield. Usually, the shields were just used to keep very large numbers of interested and friendly animals at a safe distance. Whether it was out of affection, curiosity, or just to determine if we had fish to give them, many of the animals really wanted to come up and see us.

Other animals that I photographed for this book required a little less armor. You may not know it to look at a hissing, hair-raising adult, but baby opossums are just about the snuggliest thing this side of puppies. Opossums have very few defense mechanisms other than playing dead, which can make them an easy target. Most baby opossums come to wildlife clinics because their mothers have either been hit by a car or attacked by a dog. Often the mother will be found dead while the babies are still alive in her pouch. Opossums stay in a mother's pouch for more than two months after birth, so when they lose their mother, they require constant warmth and liquid food every two hours. Holding and touching them when they're young may cause them to become affectionate with their human caretaker, but once they're older, their wild opossum instinct kicks in and they want nothing to do with you (which is how it should be), and become prepped for release back into the wild.

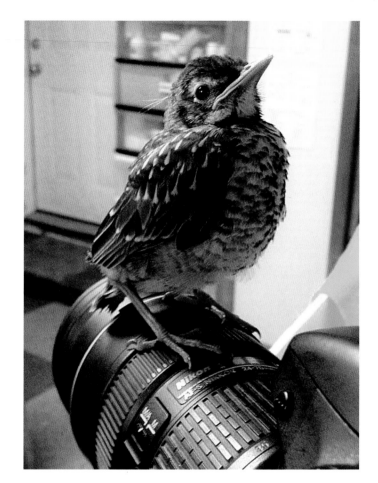

Baby bunnies are also frequent patients at wildlife clinics. Unfortunately, their rate of survival is extremely low in captivity because their stress level is so high. Well-meaning people often find nests of seemingly abandoned bunnies in fields and grassy areas. With no mother in sight, it is assumed that they are orphaned, but in fact, they are usually fine. Mother rabbits have very rich milk and only need to nurse their young once every twenty-four hours, usually at night or near dawn. The rest of the day, the mother rabbit stays away from the nest because her presence will attract predators. The baby bunnies are snuggled together and usually nestled in a bed of straw or grass to keep warm. There they wait until their mom, who is almost always foraging nearby, comes back to feed them.

Deer have a similar approach to child rearing. Like rabbits, deer mothers will leave their fawns alone during the day while they go off and feed, rejoining them at twilight. The fawns are usually left in tall grass, where they rest until their mom comes back to nurse them. Every year, thousands of fawns are needlessly taken from the

wild and brought into wildlife clinics—or worse, into people's homes—because they were found alone. In fact, in more cases than not, the fawn's mother was probably nearby, hiding behind a tree or a shrub. Wildlife experts caution that unless you know for sure that a mother deer is dead, you should not remove a fawn from the wild. Its best chance of survival is with its mother.

Some of the rarest animals to show up in wildlife clinics are foxes. Perhaps because of their highly elusive nature or much lower population numbers than other forest-dwelling mammals, these graceful members of the Canidae (dog and wolf) family are unusual to see in the wild, let alone up close. However, over the two-year span of making this book, I finally got to meet a baby fox. Piper, as she was later named, was brought in by a local woman who had witnessed the little fox's mother being fatally wounded by a car. The fox kit was in the mother's mouth at the time of the accident. Whether it was due to the impact of the crash or a birth defect, Piper has detached retinas and is blind.

Piper is now being raised by the Buttonwood Park Zoo in Massachusetts to be an "education animal," which means she will not be on display at the zoo, but rather will make appearances at educational events and talks. The little fox, who was only a few weeks old when I first met her, is the charge of two female staff members at the zoo who keep her in the office with them during the day, where she plays, sleeps, and goes on walks in a harness; in short, most of the things that a pet dog would do. At night, Piper stays in a large kennel enclosure where she has a bed and many toys aimed at keeping her mentally stimulated.

I have photographed Piper several times now, and have seen her morph from a clumsy baby terrified of any sounds or movement to a confident, bushy-tailed juvenile who leaps and pounces and hunts. Although she is blind, she instantly recognizes her caretakers by smell. When one of them approaches, she gets all wiggly, play-bowing like a dog and whining. Her reaction to people whom she does not know well is very different

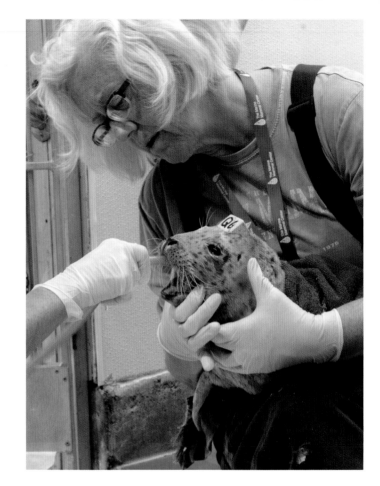

and much more defensive. She will growl and snap if you get too close or try to touch her. Even with her caretakers, she does not want to be cuddled or petted. Her affection for them is strong and undeniable, but Piper is a wild animal, and her instincts still govern most of her actions.

Whenever Piper is brought to an education event, the staff emphasizes her wild nature and reminds audiences that it is illegal to bring wildlife into your home. They try their best to dissuade audiences from wanting a pet fox, but no matter how many facts they provide (a fox's urine smells like skunk; they do not housebreak; they can cause serious injury), some people don't want to listen. The lure of having an intimate encounter with a wild animal is often too great of a temptation. It is crucial to remember that no matter how much you may want to cuddle a fawn or feed fruit to a gaping baby bird, unless you are a licensed wildlife rehabilitator, it is against the law to do so, even if you just want to help.

Wild Babies focuses largely on indigenous American wildlife. The photographs in the following pages are a celebration of everyday wonderment and beauty. Although most of us have been awed by exotic animals—a tiger cub or newborn chimp at a zoo—how many people actually get to see a baby mouse or raccoon or opossum? By giving readers an opportunity to see indigenous wildlife species at a rare and fragile time of life, I hope to foster more compassion and tolerance for animals of all ages. Baby animals like the ones pictured in the following pages may be irresistible to us now, but they will grow to be bigger, less cuddly creatures. The next time you find a deer eating your garden or a raccoon rummaging in your garbage, remember that feeling of compassion—and extend it to the grown-ups.

It's not always easy. Adult wild animals are wired for survival and are often much more defensive and nervous than babies, but they are adapting to survive in a world dominated by humans, and sometimes need a little compassion. So the next time you see that scary adult opossum hanging upside-down from your garage or find a creepy bat in your attic, remember that they were once tiny, helpless, cute babies—and cut them some slack.

COYOTE

Eight weeks old

Coyotes live in nuclear families within a larger pack structure. During breeding season, they make their dens in rocky crevices, hollow trees, and shrubbery. When babies are born, both the mother and father help to care for the pups. Sometimes older siblings will also help. After the pups are weaned, the family abandons the den, but may come back to use it again the following year. Coyote pups are considered mature at about nine months, at which time some will leave home while others will continue to live with the pack.

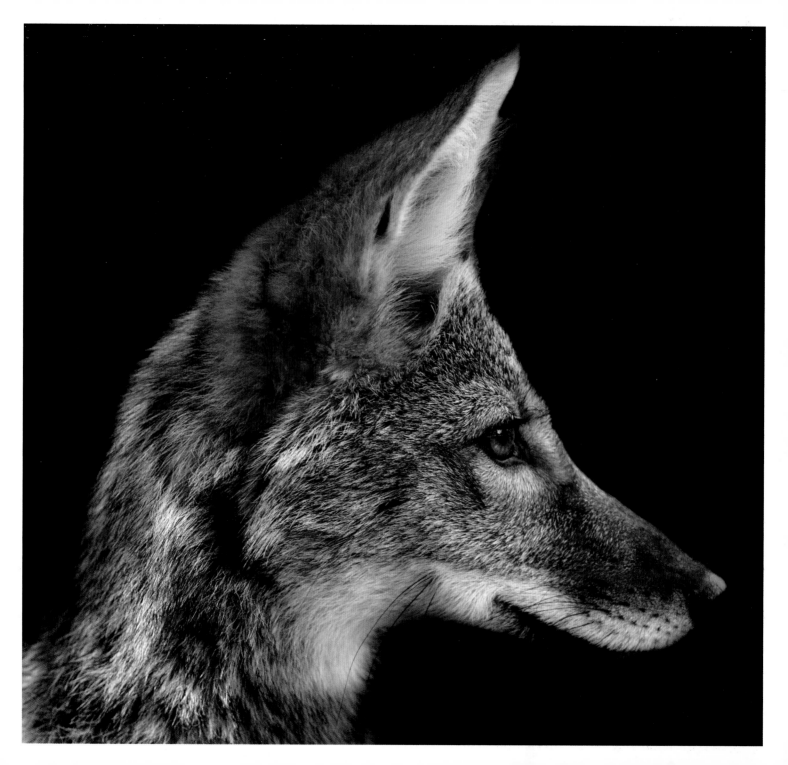

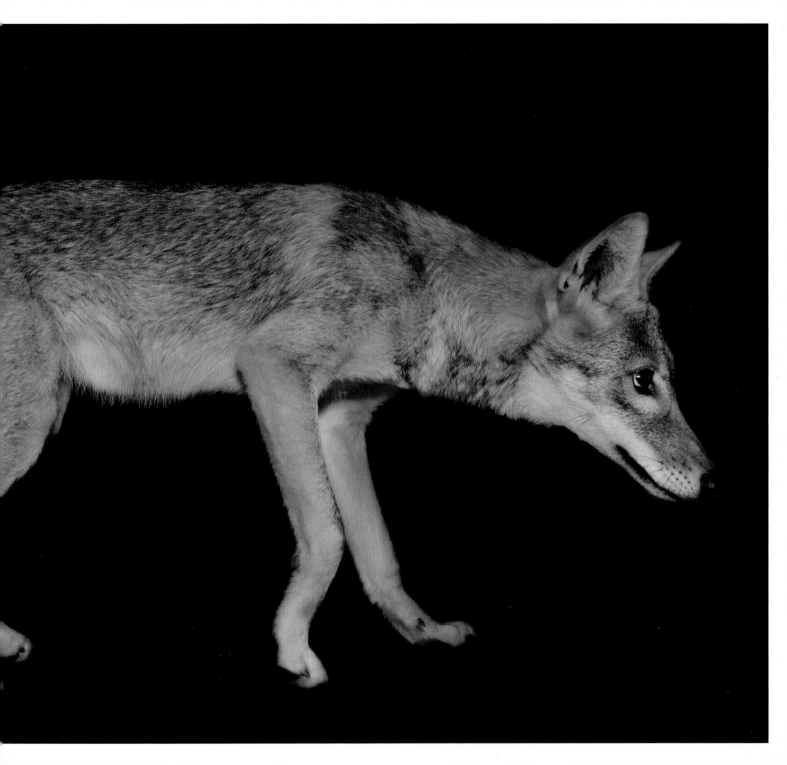

MALLARD DUCKLING

One week old

When a duckling hatches it will imprint upon the first living creature it sees that is larger than itself, which is usually the mother duck. Ducklings are able to walk and swim just hours after hatching, but will stay with their mothers and siblings, often parading in a line when walking and swimming, for a few weeks. Ducklings usually take their first flight at about two months old.

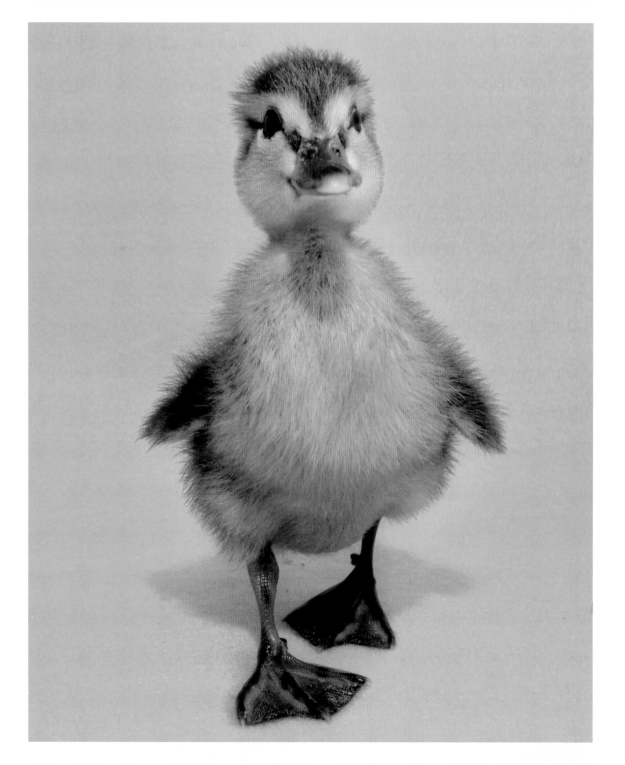

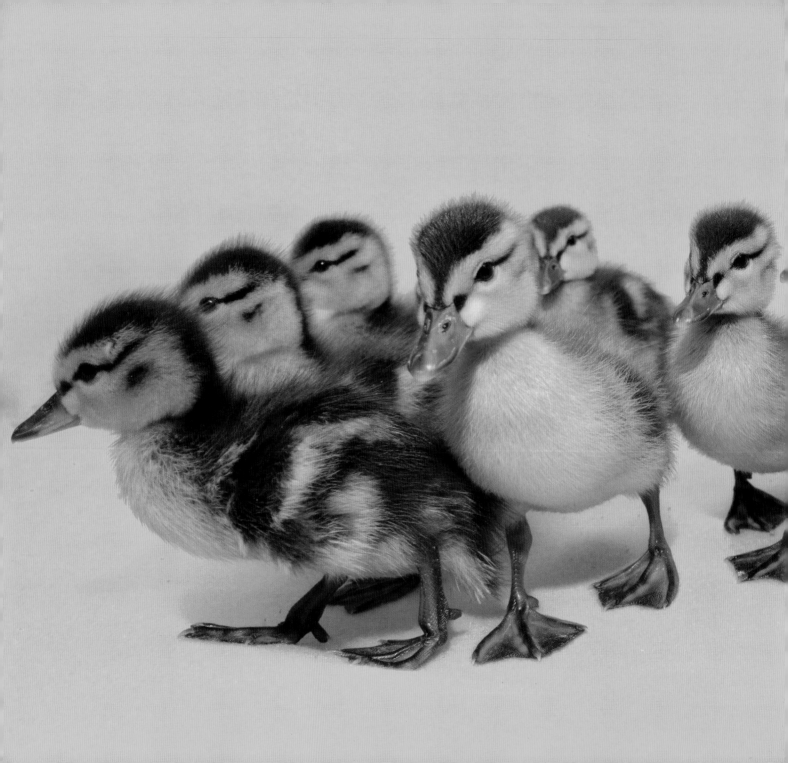

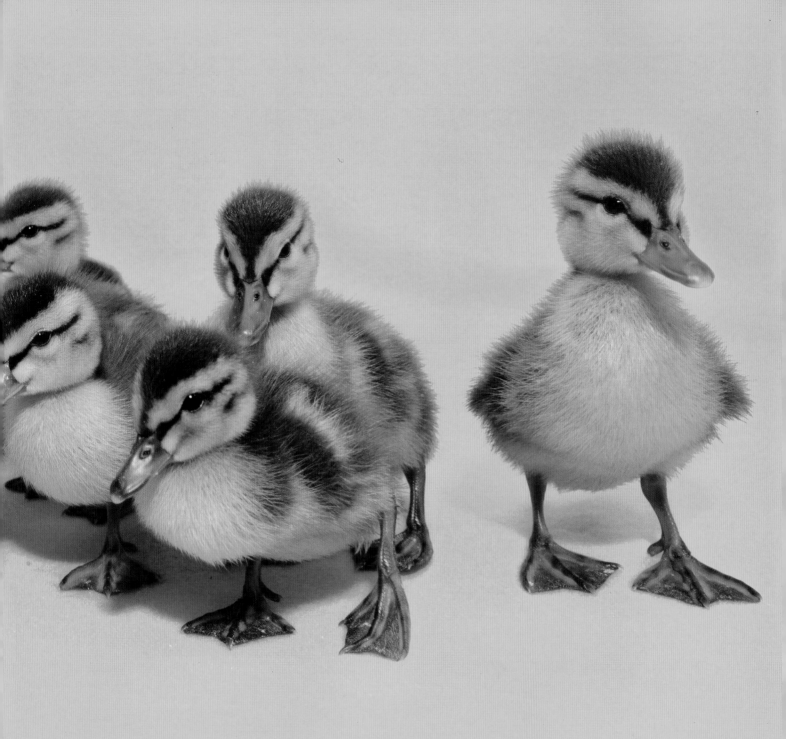

HARBOR SEAL

Two weeks old

Harbor seals are long-lived, with lifespans reaching twenty-five to thirty years. During their lives, adult females can give birth to one pup every year. Harbor seal pups are able to swim at birth, but will often ride on their mother's backs when they are tired. Pups form a strong bond with their mothers and are very vocal, making a bleating noise that sounds like "maaaa" to communicate with their mothers.

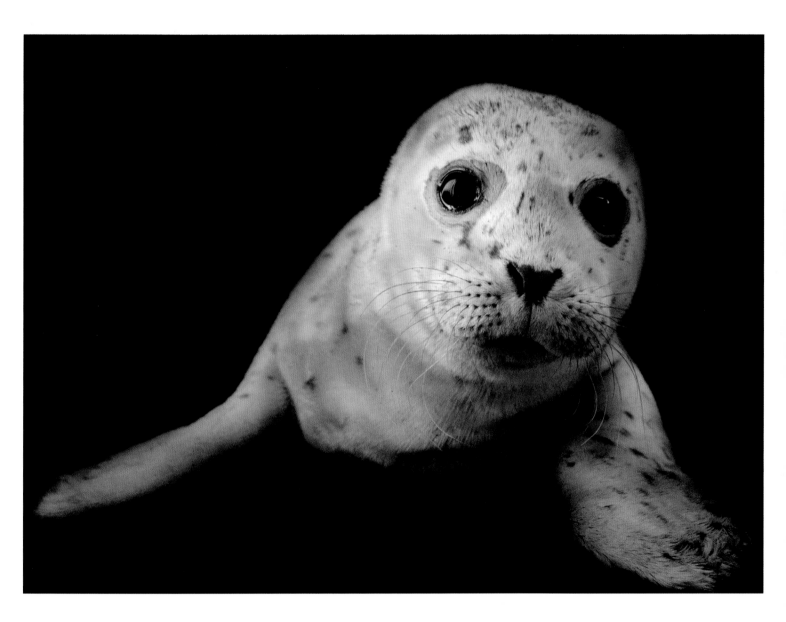

GREEN HERON

Three weeks old

Green herons are one of the few species of bird that builds and uses tools. They create fishing lures out of twigs, crusts of bread, feathers, or other detritus, which they then dip in the water to entice fish to the surface. Green herons are seasonally monogamous, and perform elaborate courtship displays to attract a mate. This behavior often includes calling, snapping their bills, and craning their necks. Once pairing and mating have occurred, both parents help incubate and feed the hatchlings, which will remain with their parents until they are about one month old.

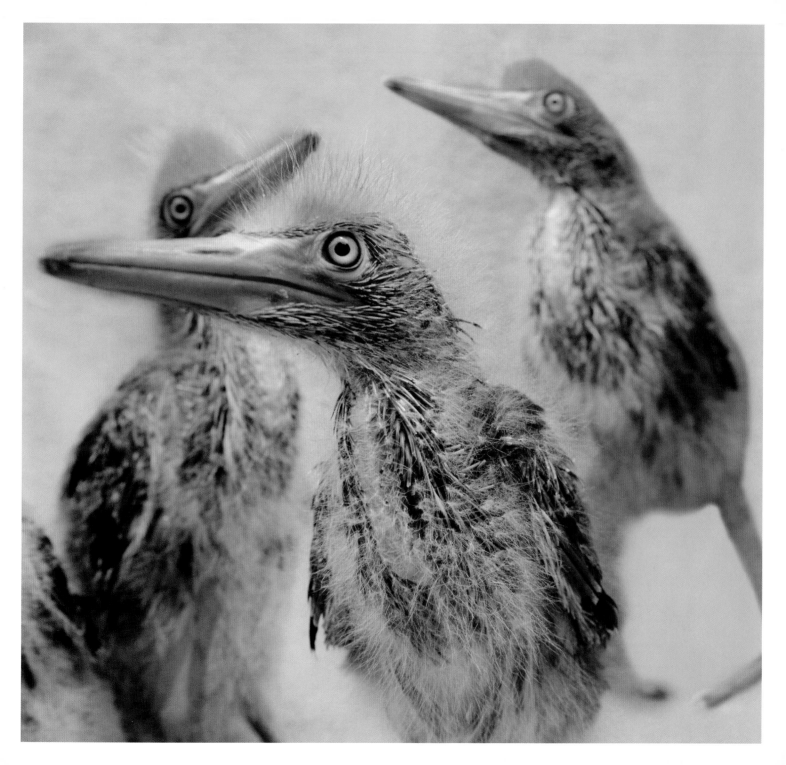

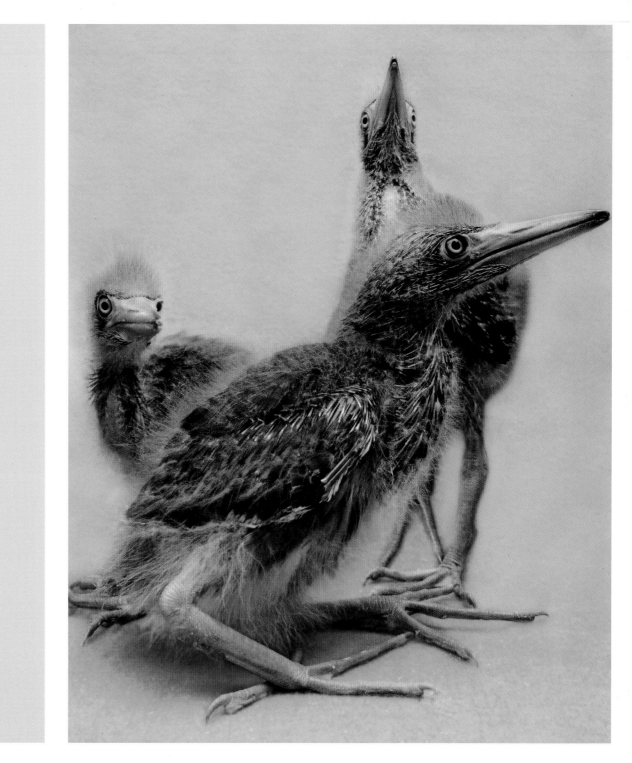

RED KANGAROO

Four months old

Kangaroos are the world's largest marsupials, but at birth are about the size of a cherry. Born blind, hairless, and less than an inch (only a few centimeters) long, the joey immediately climbs into the mother's pouch to nurse, and remains there for up to six months. The joey will spend a few weeks just poking its head out of the pouch, and then progress to spending increasingly more time in the outside world. It won't be until almost a full year after birth that the young kangaroo will leave the pouch for good.

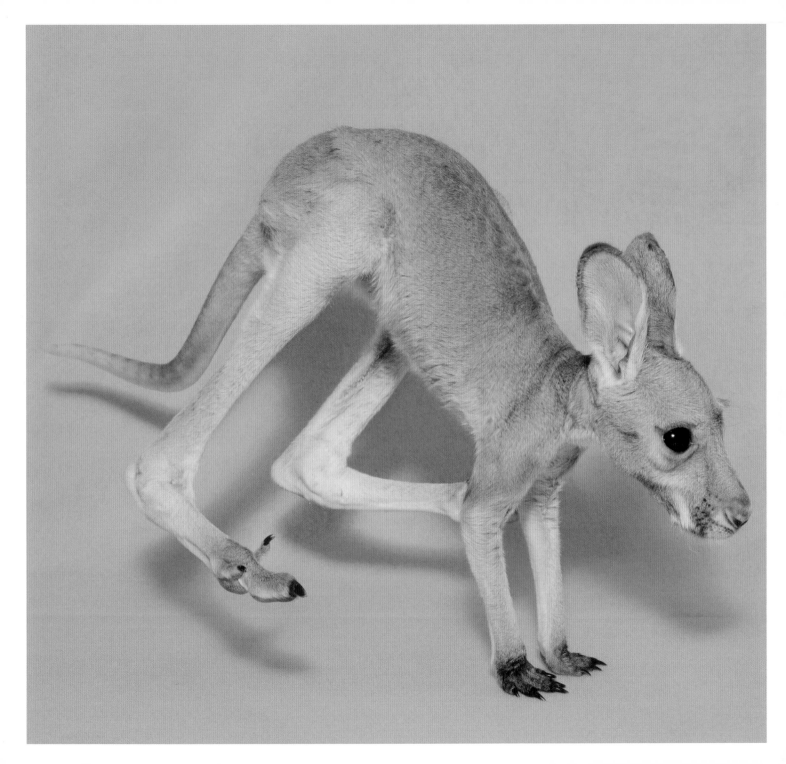

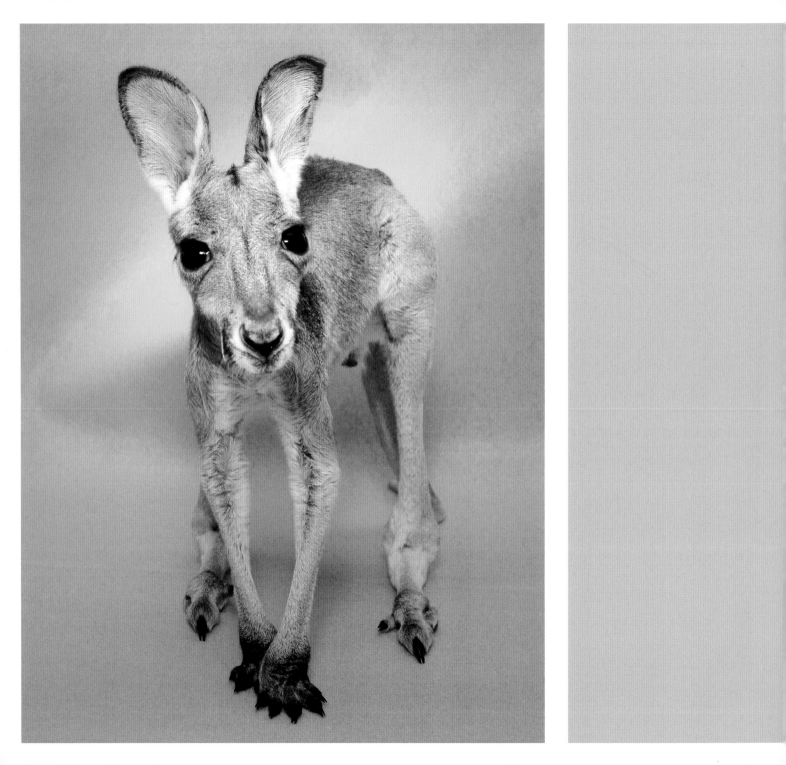

PAINTED TURTLE

*Less than
one year old*

Painted turtles are cold-blooded and therefore regulate their body temperature via their environment. They often gather in groups, basking in the sun for warmth. When cold weather comes, the painted turtle burrows under the ground or under a body of water and hibernates until spring. While in hibernation, their body temperature stays at about 43° Fahrenheit (6° Celsius) and they do not breathe—they're able to survive very long periods without oxygen. Painted turtles shed pieces of their shells as they grow bigger. Turtle shells are made of bone covered by separate sections of keratin called scutes. As a young turtle grows, new layers of scutes will form, eventually causing the old ones to peel off.

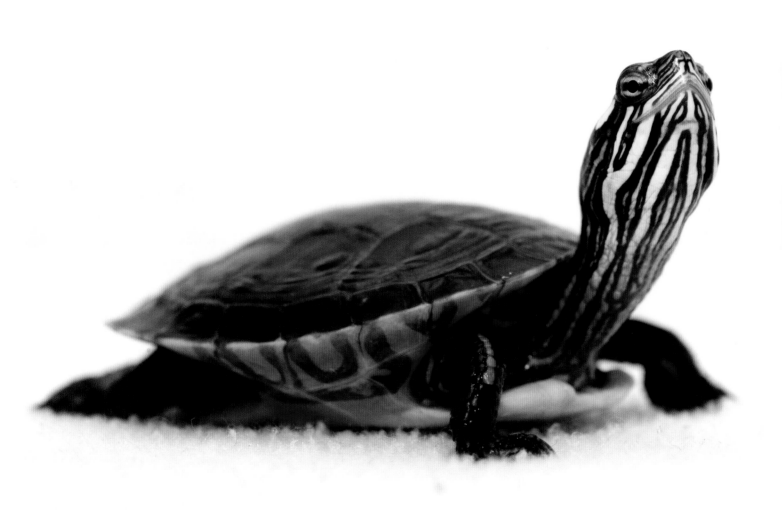

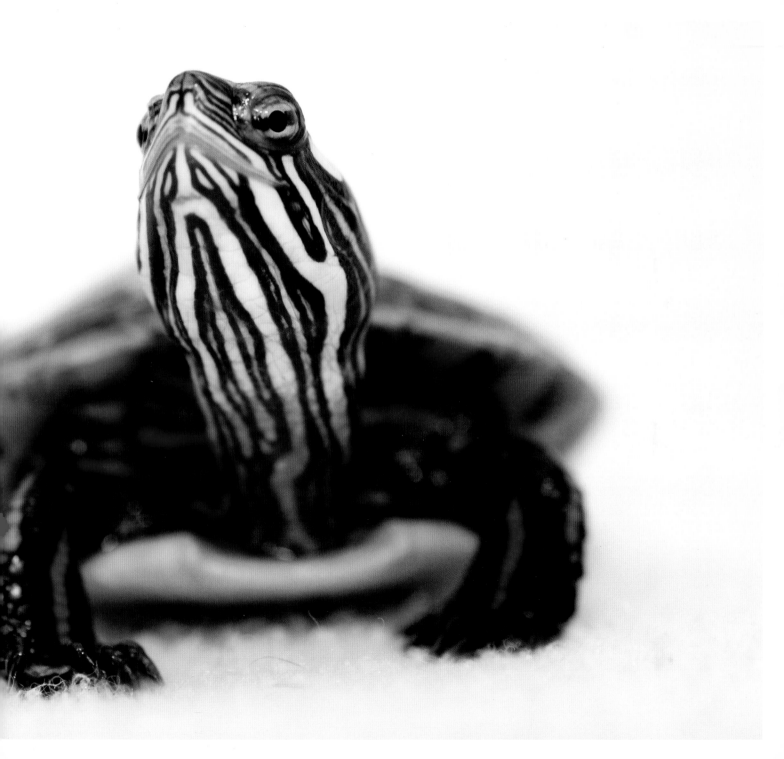

COTTONTAIL

Ten days old
Twelve days old

A mother rabbit's milk is so nutrient-rich that baby rabbits—also known as kits or kittens—only need to nurse once every twenty-four hours, usually at night. The mother rabbit does not stay with the nest during the day, as her presence may attract predators, so generally the babies are covered with leaves or grass until Mom returns.

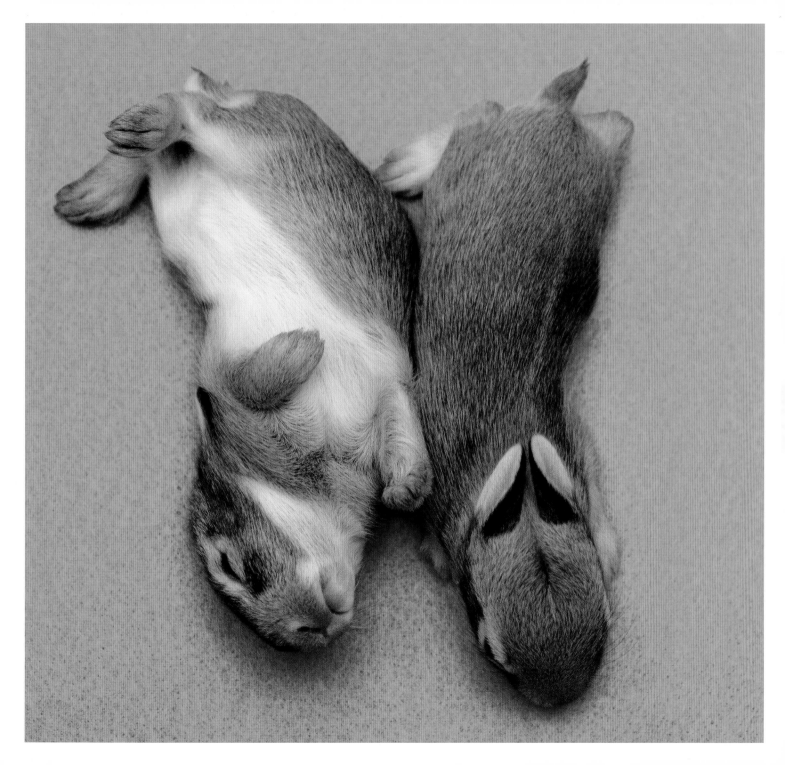

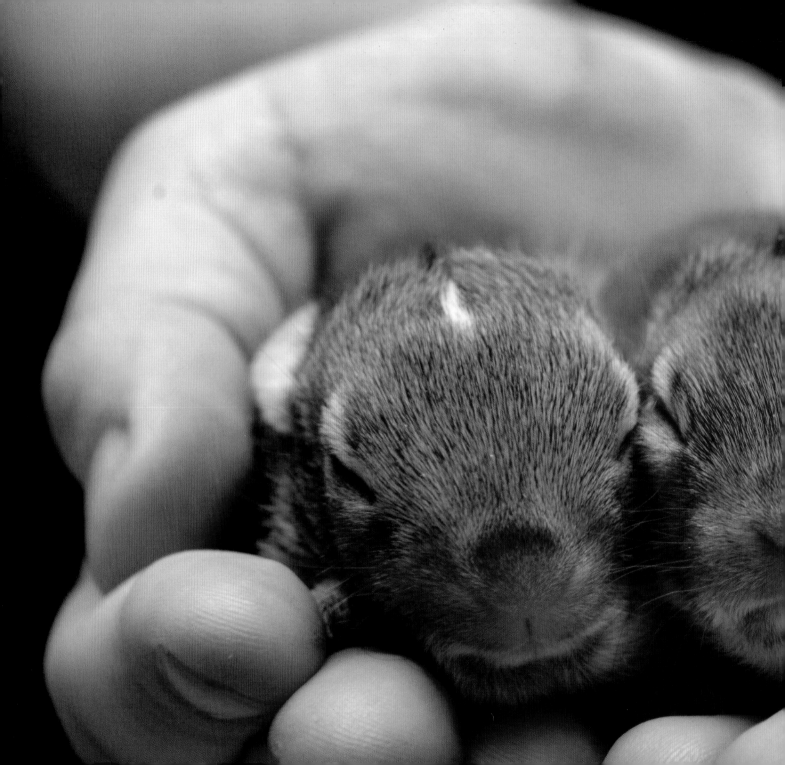

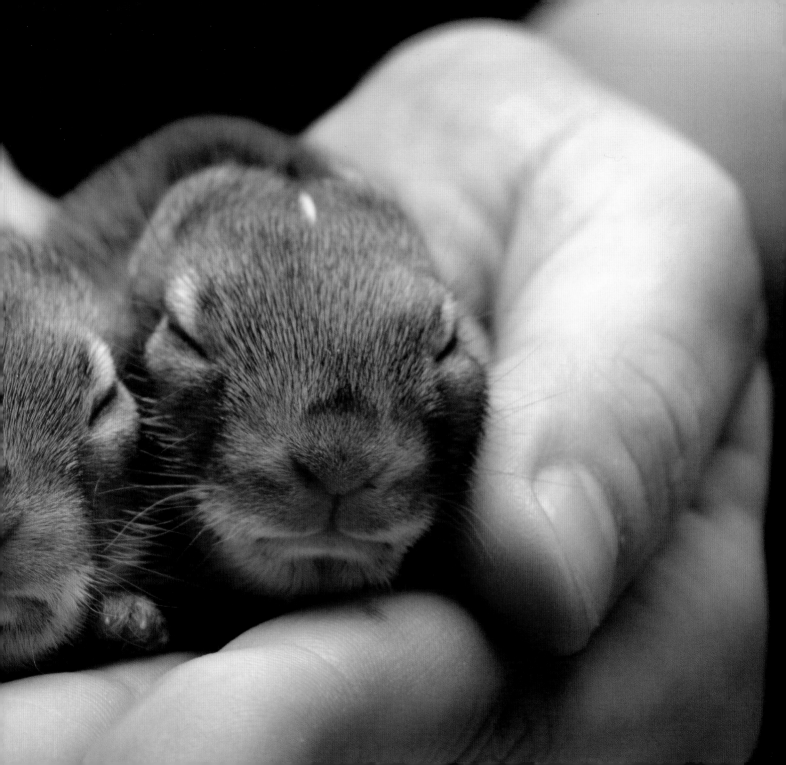

SEAGULL

Two weeks old

It is rare for people to see a baby seagull because, like pigeons, they are kept in the nest and closely guarded by their parents until they are old enough to fly, at which time they are almost full-grown. Juvenile seagulls may be the same size as an adult, but will be covered in brown feathers instead of white.

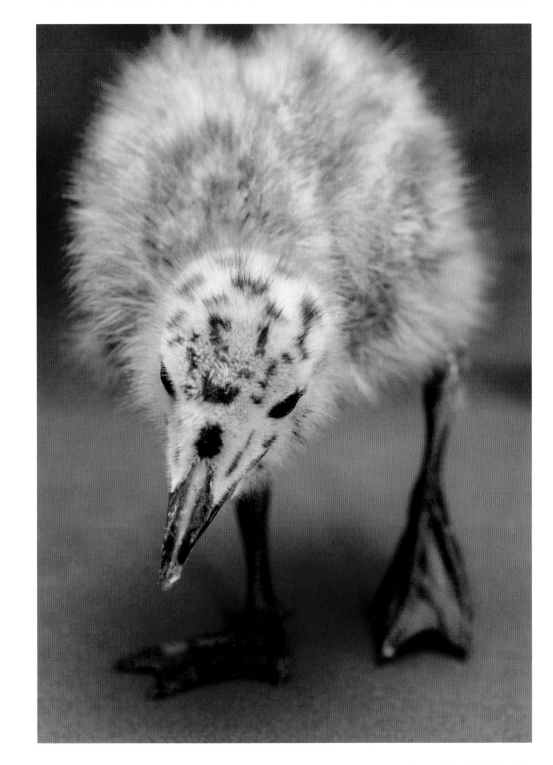

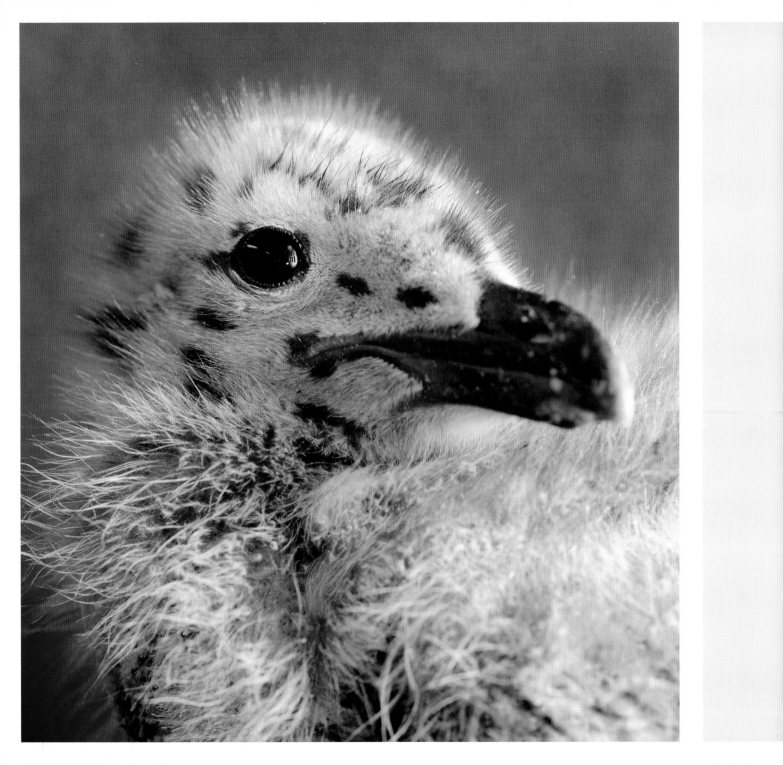

RED FOX

Eight weeks old

Red fox kits are born blind, deaf, and unable to regulate their own body temperature. The mother stays with her kits twenty-four hours a day for up to three weeks after giving birth, during which time the kits' father or another female from the family will feed the mother. Females from the litter will often stay with the family to help with the next year's litter, while males will leave the family as juveniles to go and start their own families.

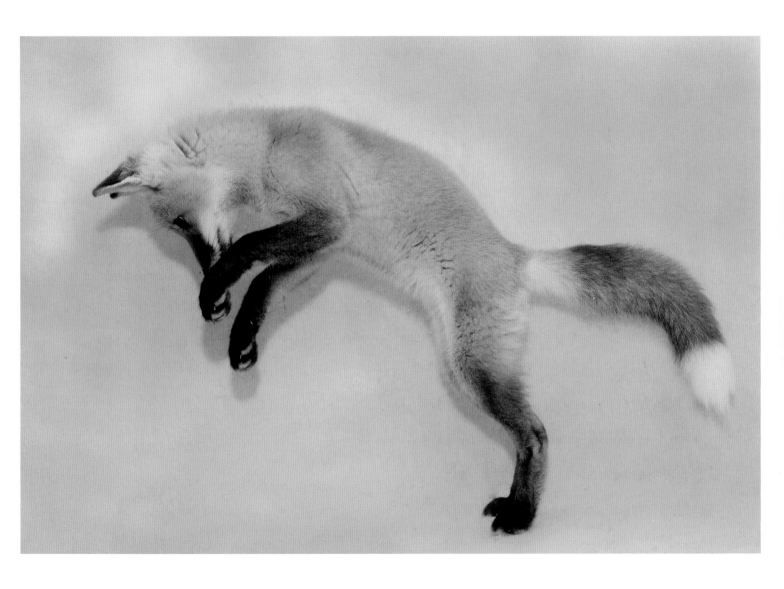

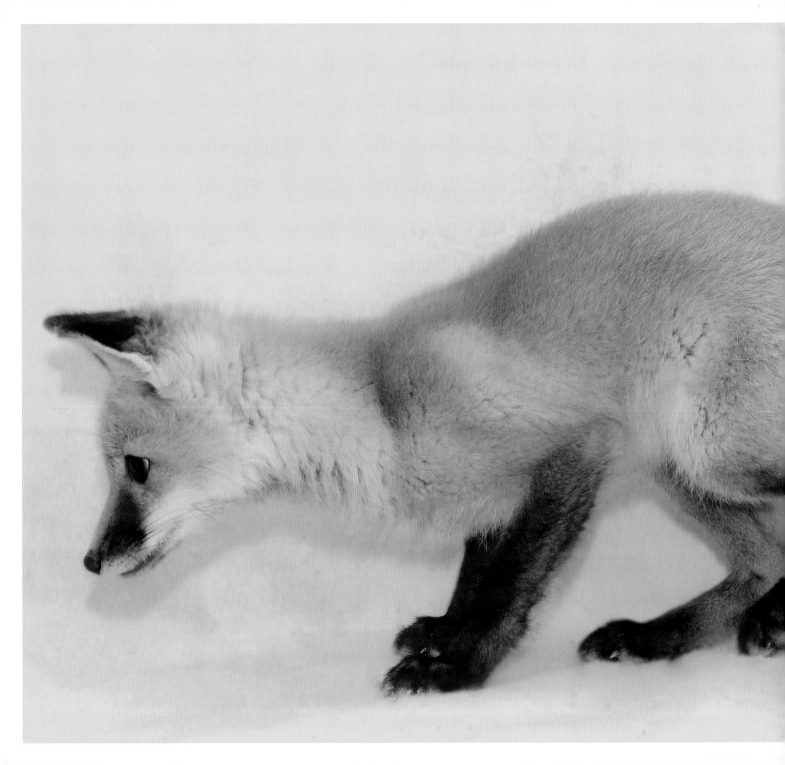

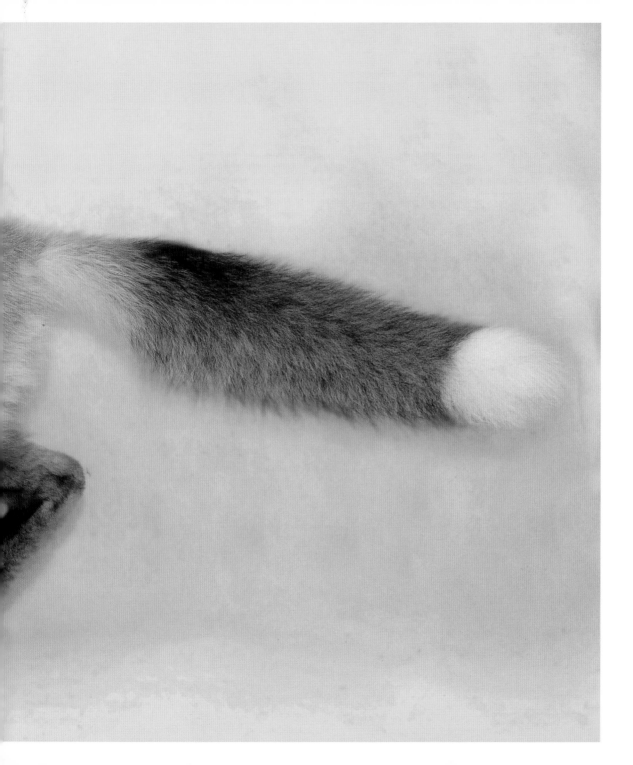

EASTERN RED BAT

Six weeks old

Bats usually give birth to one baby, or pup, at a time, all while hanging upside down. Once born, individual babies are then grouped together with other babies in a maternity colony that provides pups with warmth and protection. The baby bats are left together hanging from the cave while their mothers go out at night and hunt. When a mother bat returns to the nursery, she can immediately pick out her baby from the hundreds of identical other bats in the colony just by its smell and cry.

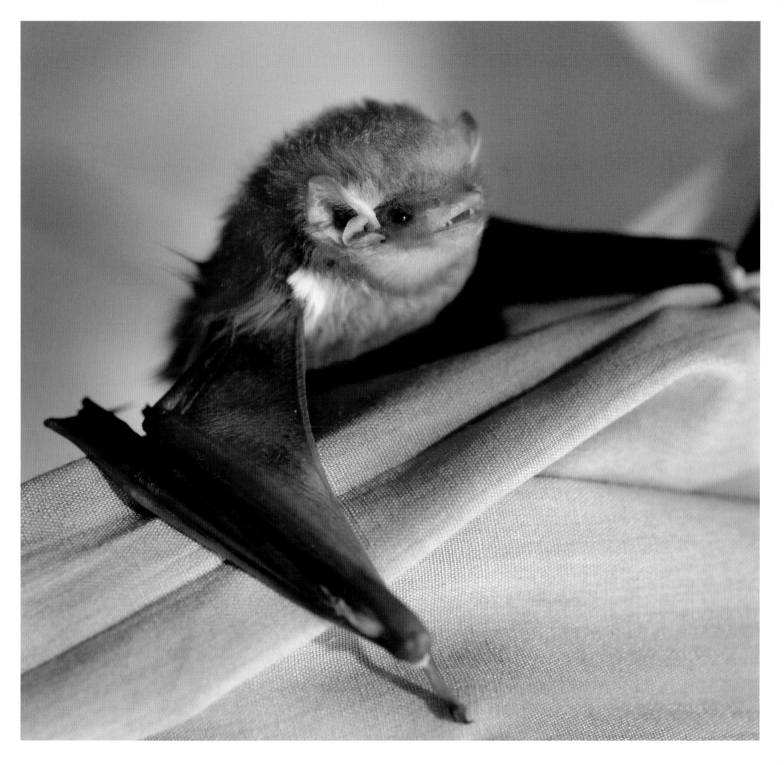

SKUNK

Five weeks old

Baby skunks are irresistibly cute but, contrary to popular belief, are able to spray even as babies—though they are unlikely to do so. Much like puppies, skunks are born blind, deaf, and covered in a light layer of fur. Their eyes open after about twenty-one days, and although they are weaned by the age of two months, young skunks often stay with their mother until they reach sexual maturity at around a year old.

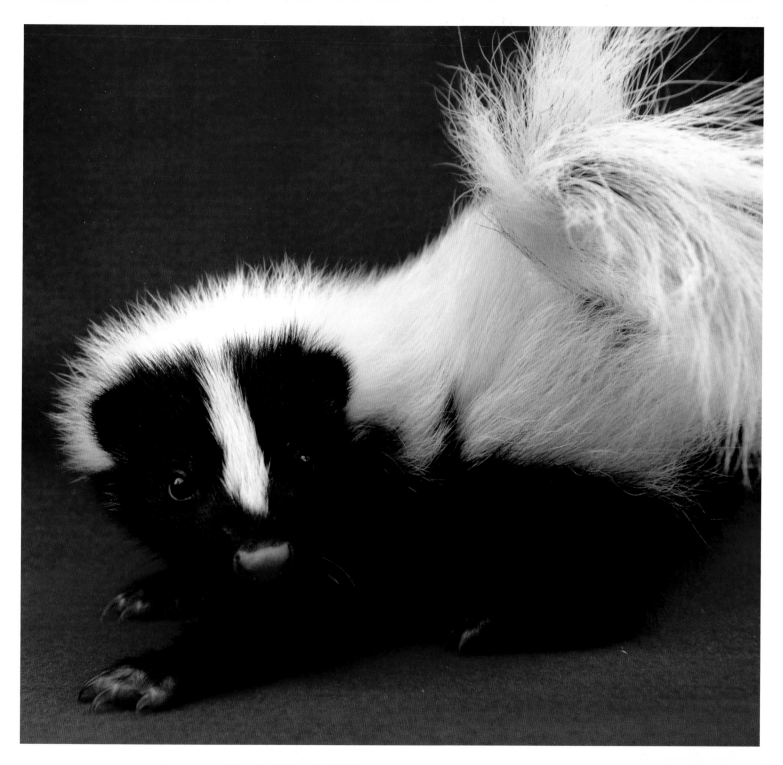

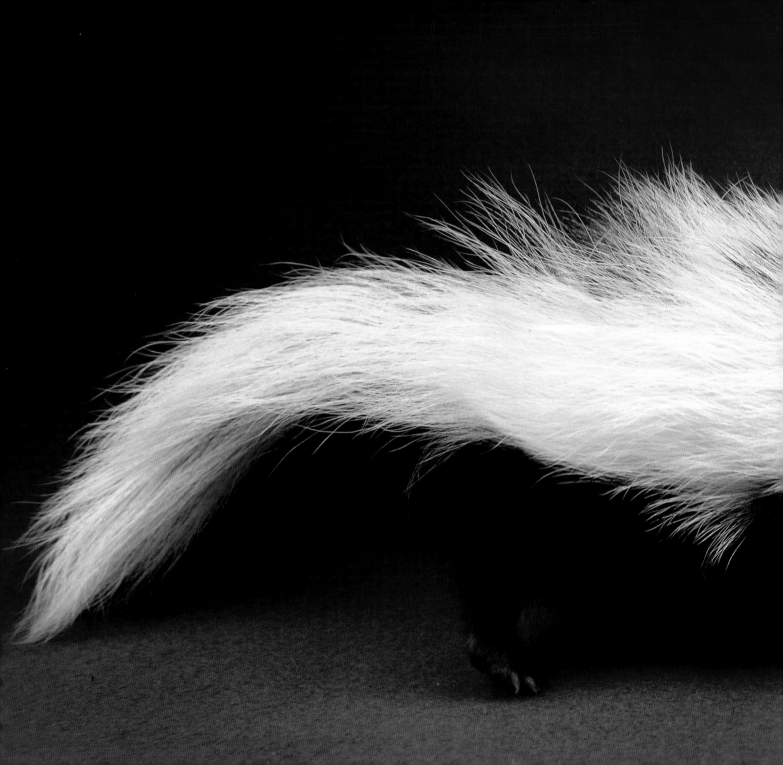

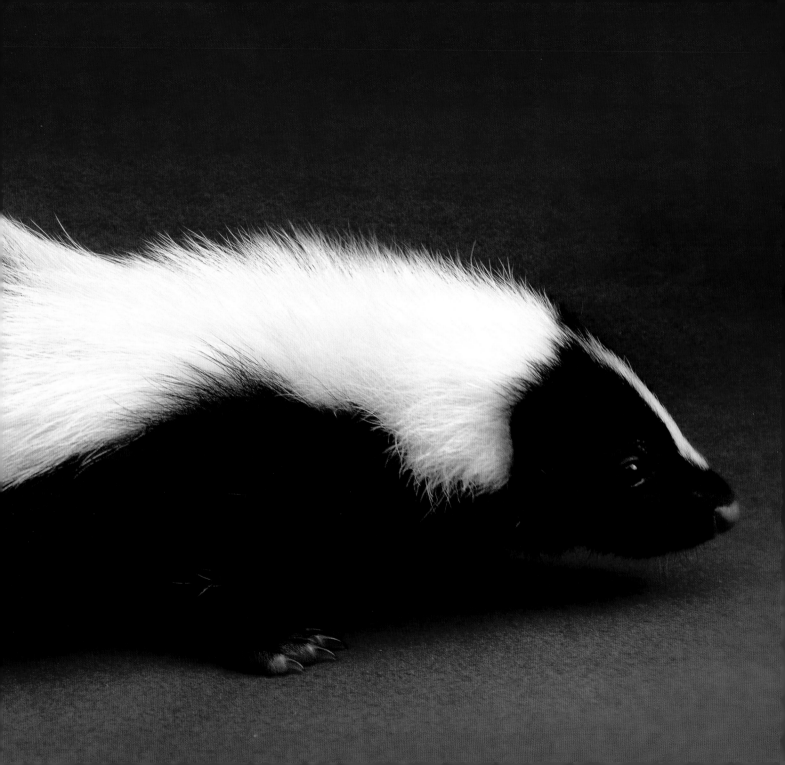

RACCOON

Four weeks old
One week old

Baby raccoon pups are very social, often bonding
with and playing with other pups. Raccoons are instinc-
tively curious and intelligent, with remarkably agile,
human-like hands that enable them to perform highly
dexterous tasks like opening gates and washing pieces
of fruit. Raccoons are very prominent in both rural and
urban areas of North America, where they are often
viewed as pests.

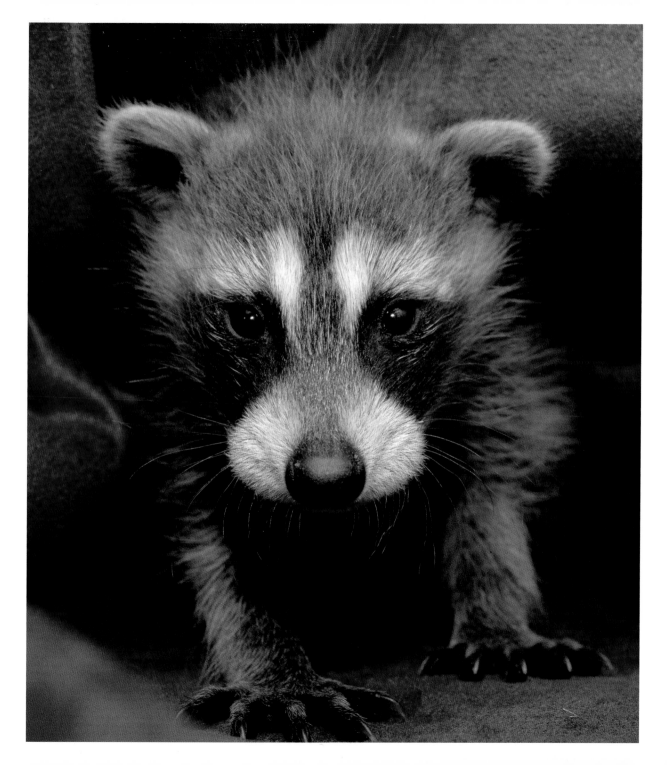

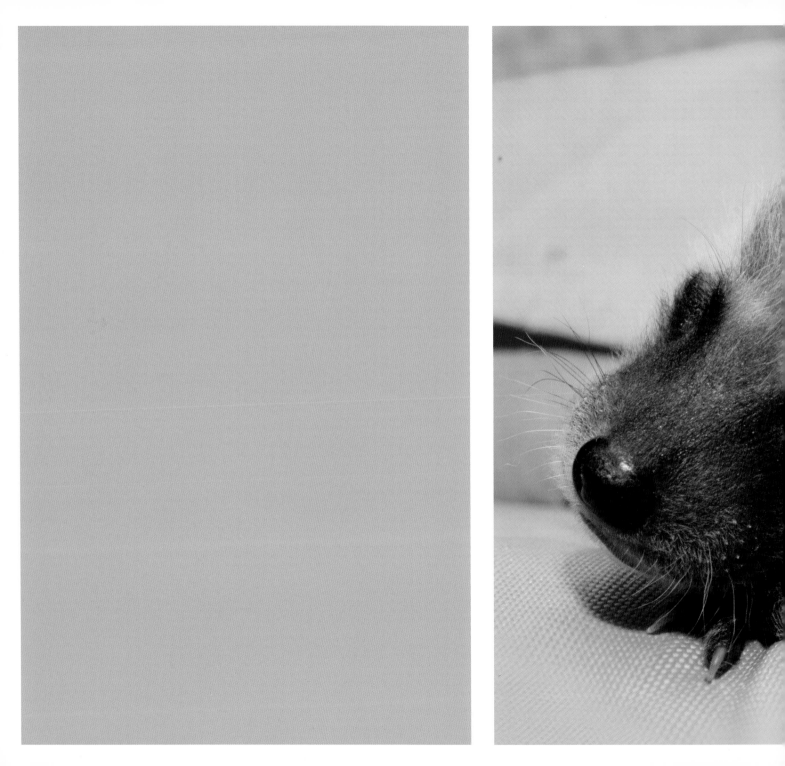

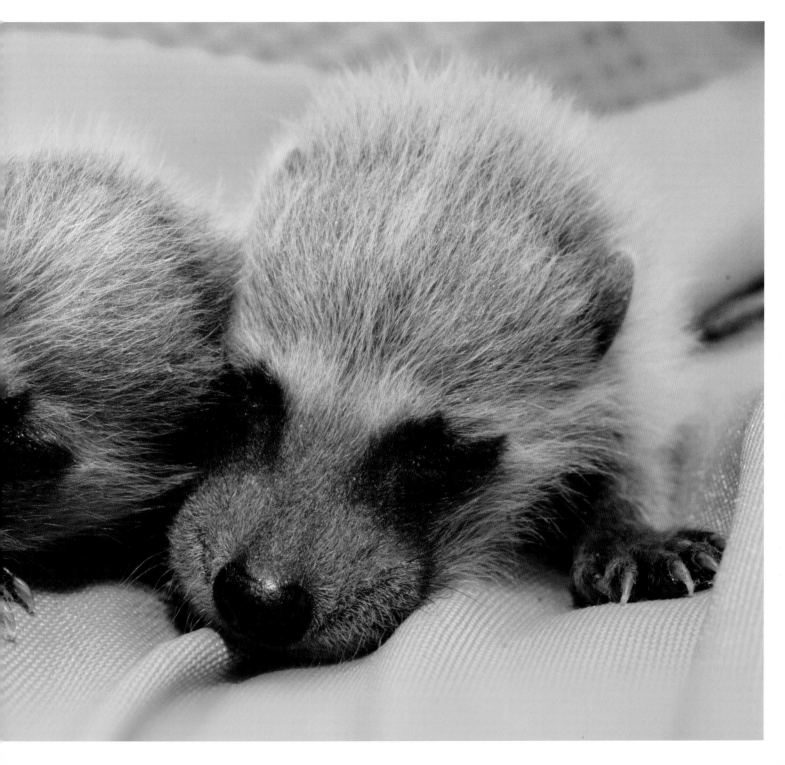

RED-SHOULDERED HAWK

Three weeks old

Red-shouldered hawks build large nests out of sticks in the forks of trees. These nests are often refreshed annually and used year after year. Hatchlings leave the nest at about six weeks old, but remain with their parents and depend on them for food and protection for another couple of months. Only half of all red-shouldered hawks will survive their first year of life. Many fall victim to natural predation by other animals, human impact, or starvation.

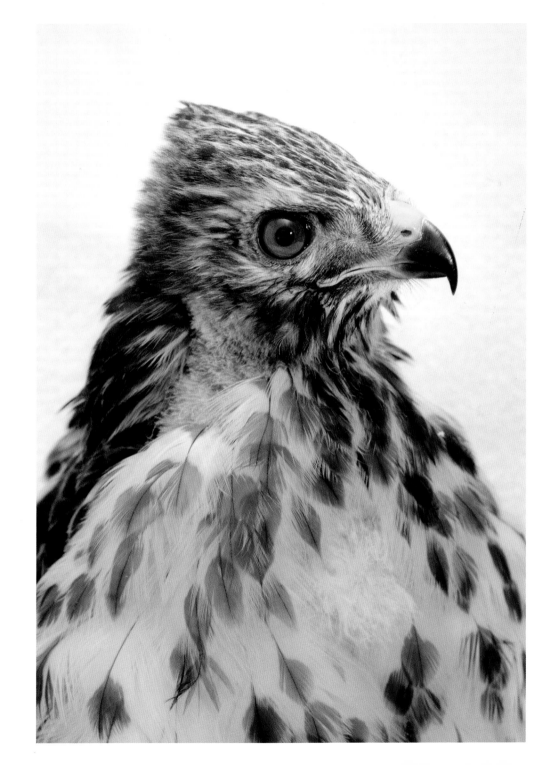

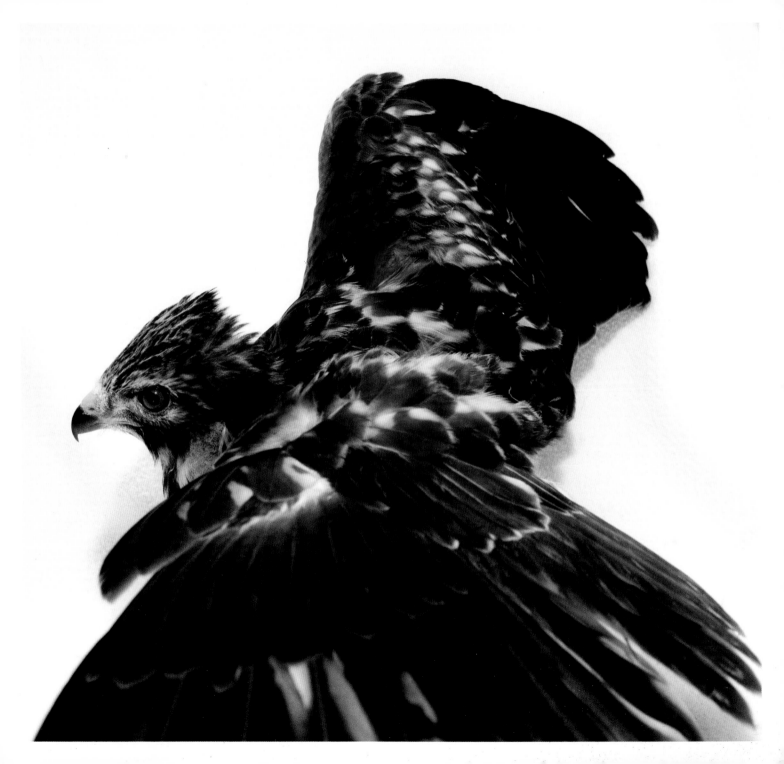

SCREECH OWL

Four weeks old
Six weeks old

These tiny owls are smaller than a pint glass as adults. Screech owls are generally monogamous, mating for life. They nest in hollows of trees, and often recycle the nests of other animals. In the nest, screech owl hatchlings fiercely fight each other for food and resources, often killing the smaller, weaker siblings.

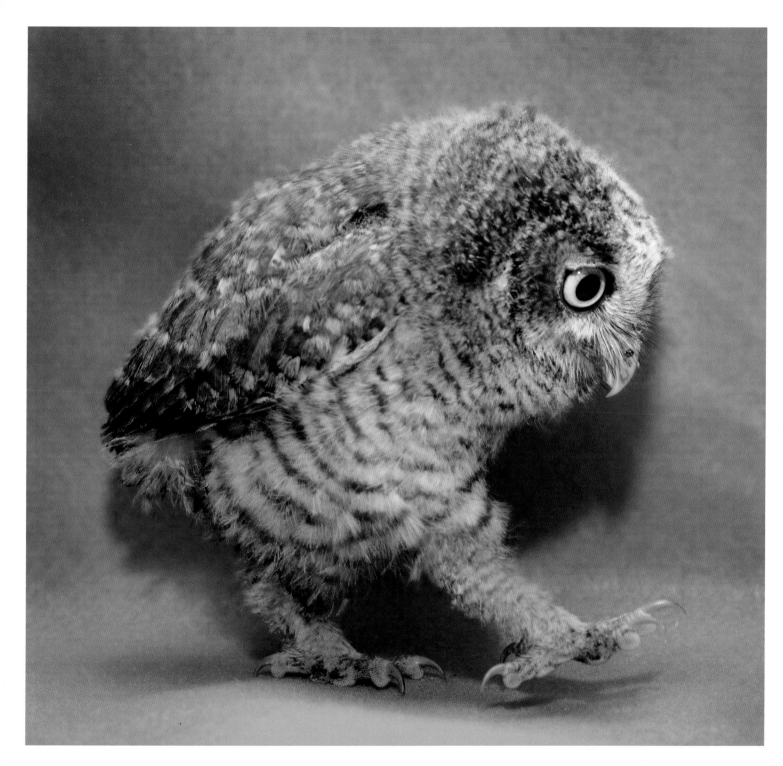

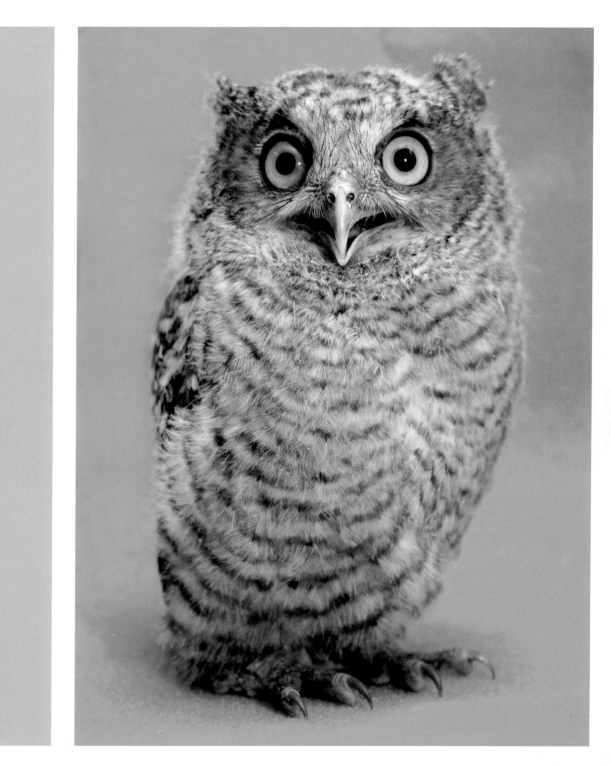

ELEPHANT SEAL

Four months old

An adult elephant seal can grow to be up to 13 feet (4 meters) long and weigh over 4,500 pounds (2,041 kilograms), so it's no surprise that they are big at birth. A baby elephant seal usually weighs about 75 pounds (35 kilograms) when it's born. Elephant seals return every year in huge numbers to the same terrestrial breeding ground, where the females give birth after an 11-month gestation period. Mother elephant seals nurse their pups for about a month before weaning them, and have been known to adopt and nurse orphaned pups who may have lost their mother.

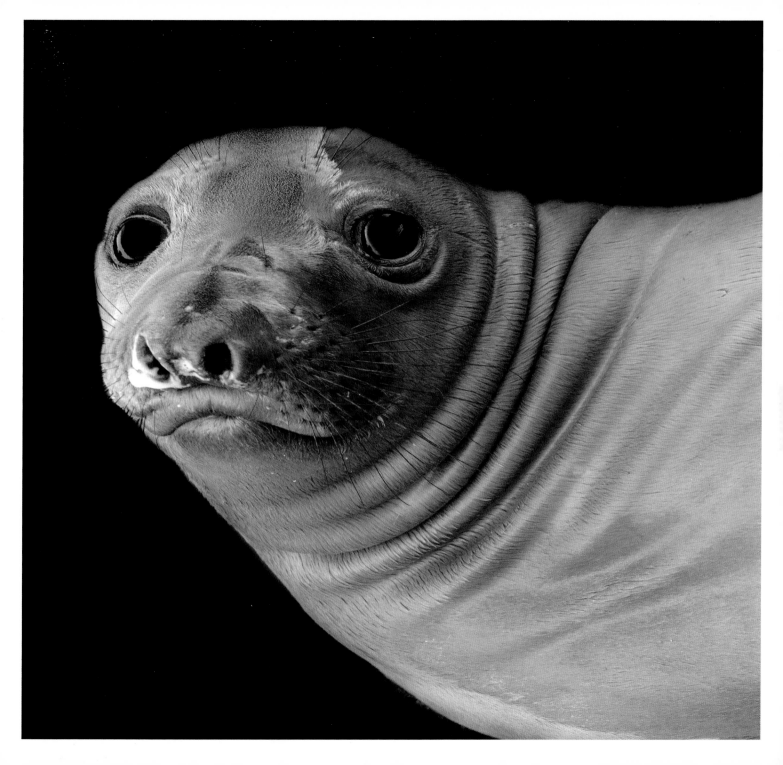

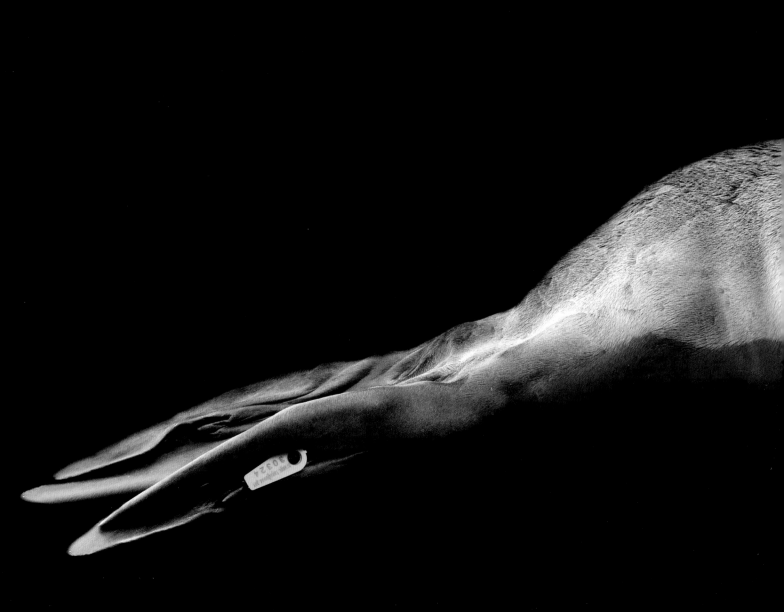

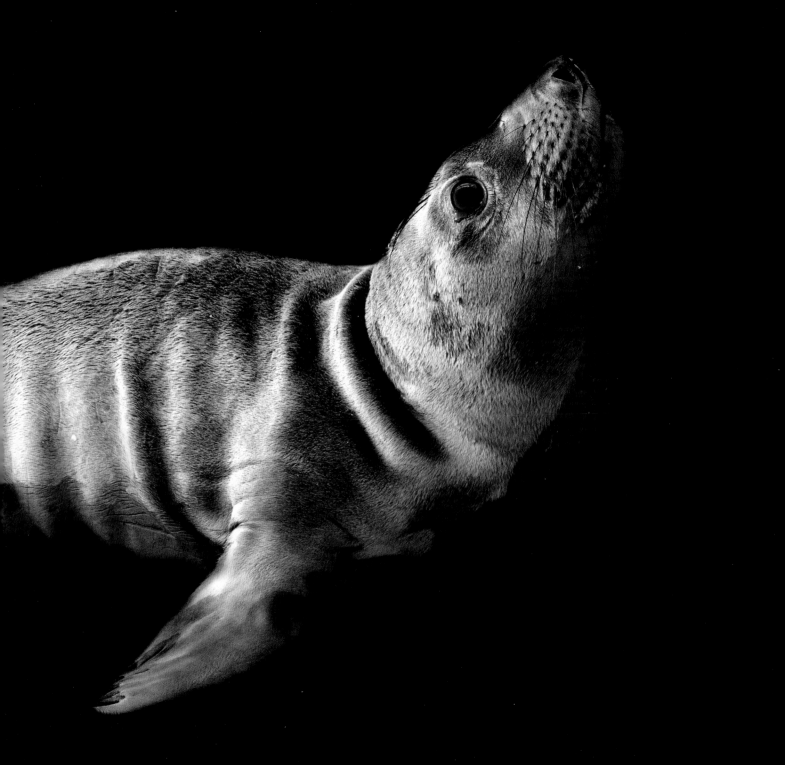

MEERKAT

Three weeks old

Meerkat babies, called pups, are born underground and
live in large matriarchal family groups in which fathers
and siblings, as well as mothers, help to raise them.
In meerkat society, there are many different roles, includ-
ing that of lookout, where one member of the family
keeps an eye out for potential predators and warns the
family of approaching danger with a bark or whistle.

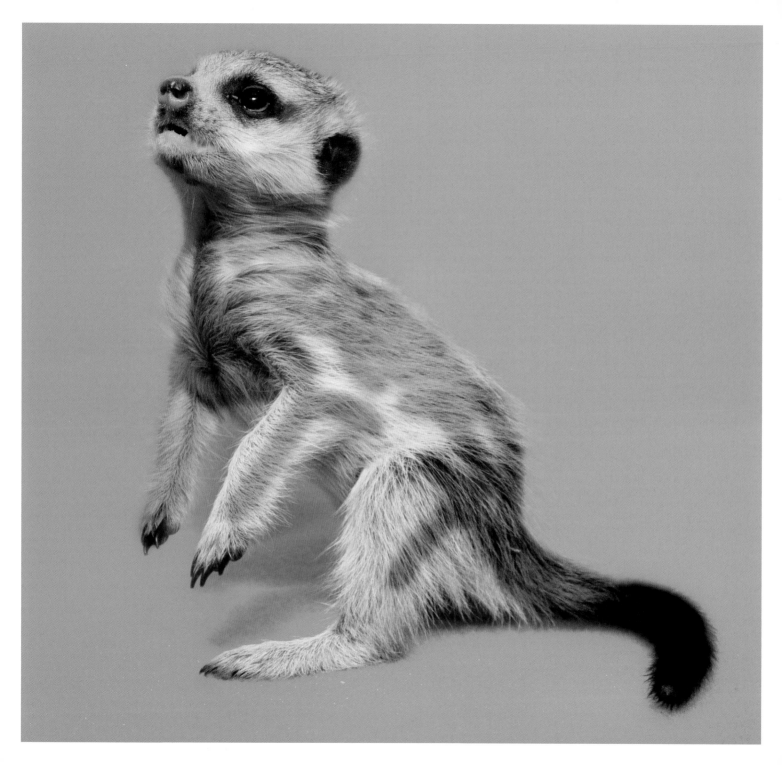

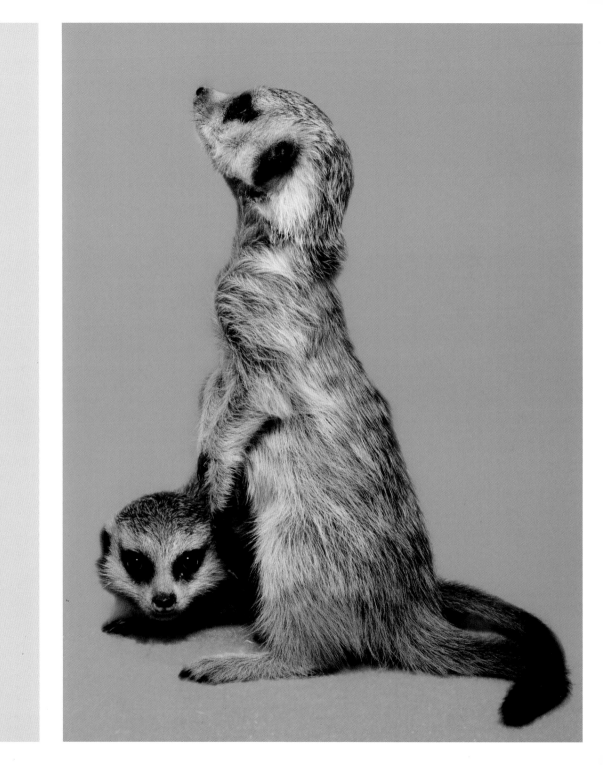

BABY ROBIN AND STARLING

Two weeks old

Fledgling baby birds are fully or mostly feathered birds that have outgrown the nest but still cannot fly. They often spend several days on the ground, where the parents continue to care for them by feeding them every few hours.

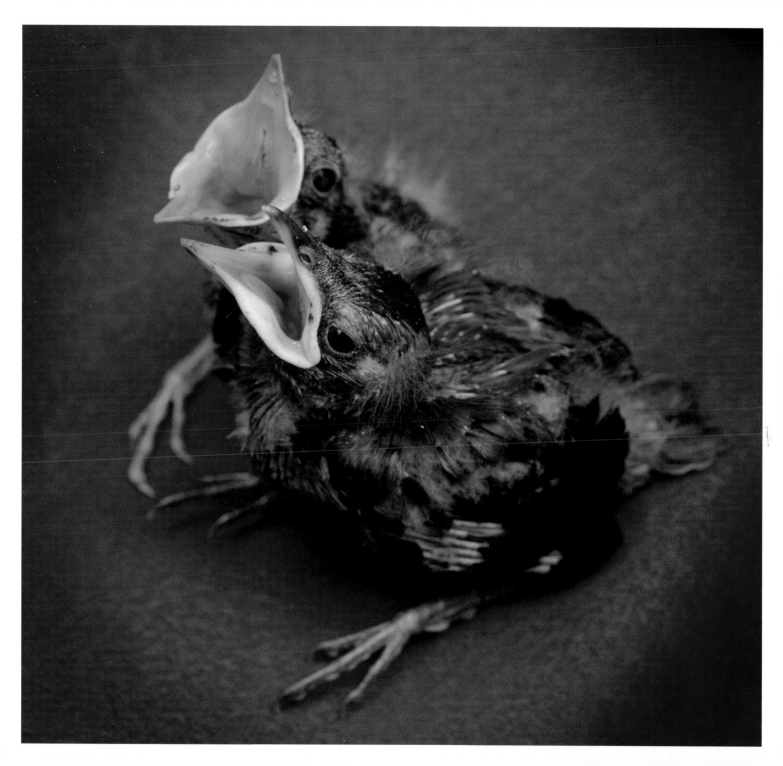

EASTERN GRAY SQUIRREL

Four weeks old

Baby squirrels are called "kittens." Kittens are born twice a year, once in the springtime and once at the end of the summer. These four-week-old baby squirrels will not be ready to be re-released into the wild until twelve weeks of age.

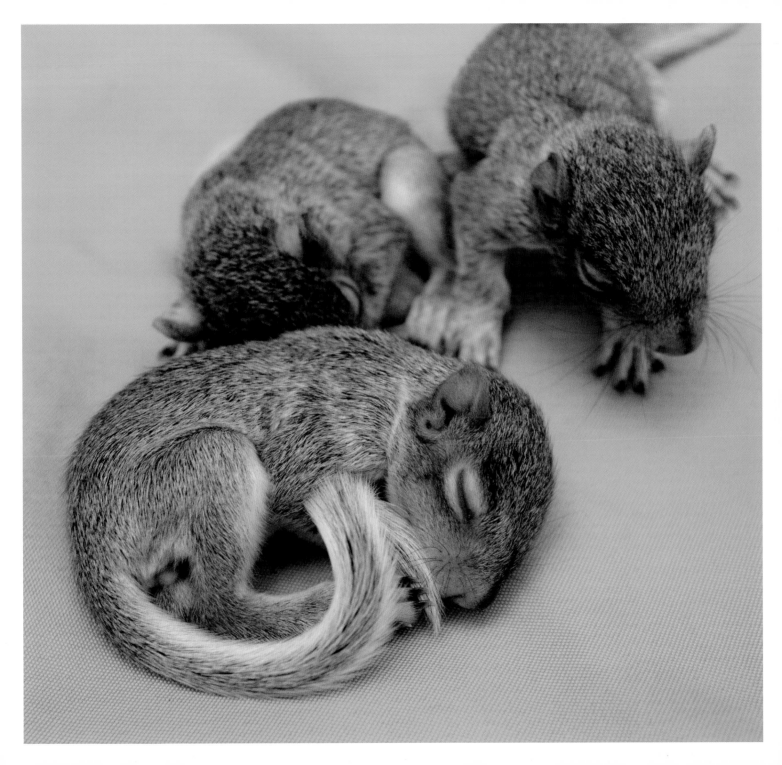

OPOSSUM

Seven weeks old
Four weeks old

These highly common marsupials are often as small as bees when they are born and will spend at least seventy days in their mother's pouch before emerging on their own. For the next month or so after leaving the pouch, the babies will spend most of their time clinging to their mother's back while she roams and forages for food. Opossums have what are called prehensile tails, which means that their tails can wrap around things and hold them. These long, hairless tails enable baby opossums to climb and hang from trees without falling, but young opossums will not actually sleep hanging upside down until they are adults.

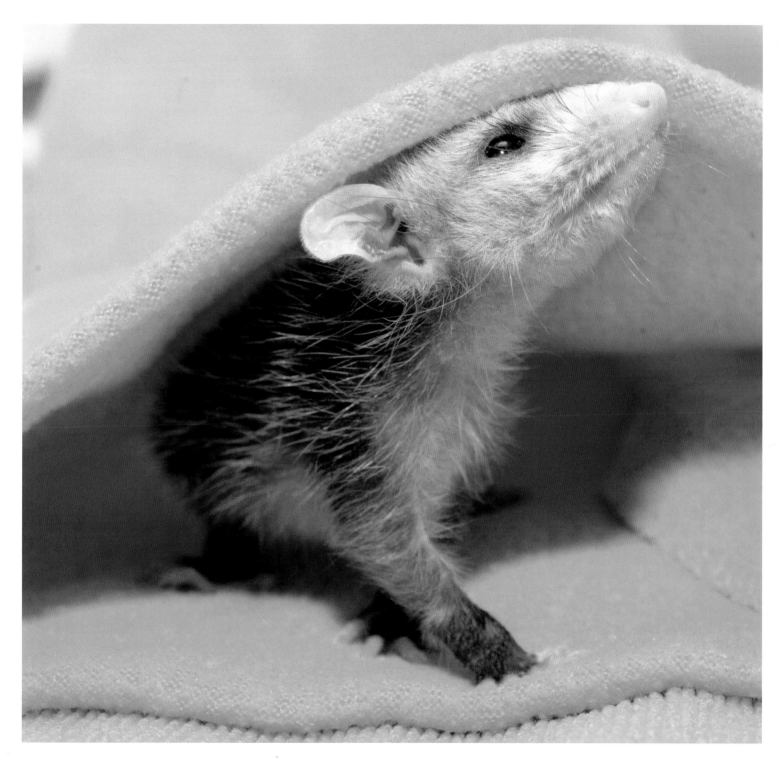

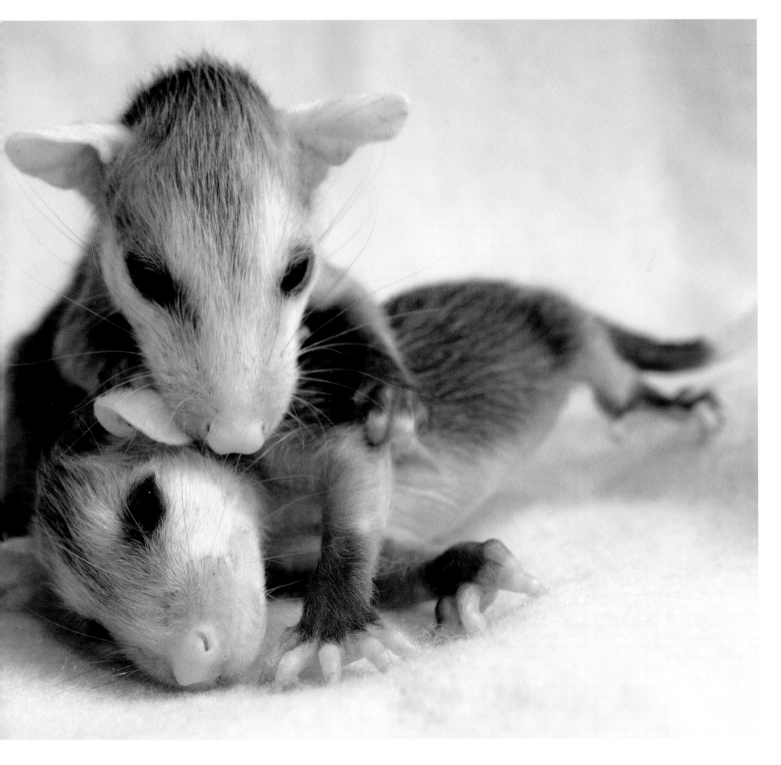

GROUNDHOG

Five weeks old

These hibernating mammals, also known as woodchucks, are the largest of the squirrel family. During periods of hibernation their heartbeat often slows to five beats per minute, for months. Despite the popular ritual that looks to the emergence of the groundhog for a weather prediction, neither temperature nor weather actually determines when a groundhog emerges from hibernation. Instead, they are driven by the start of mating season.

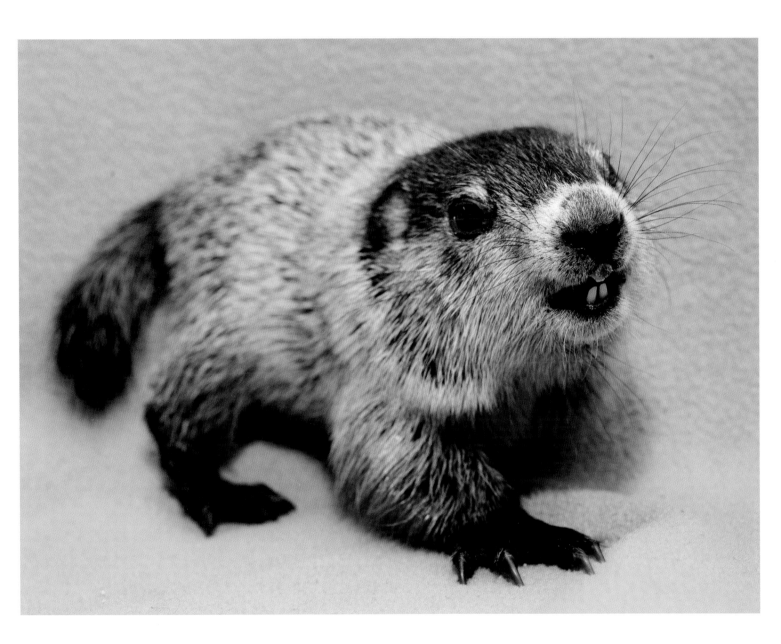

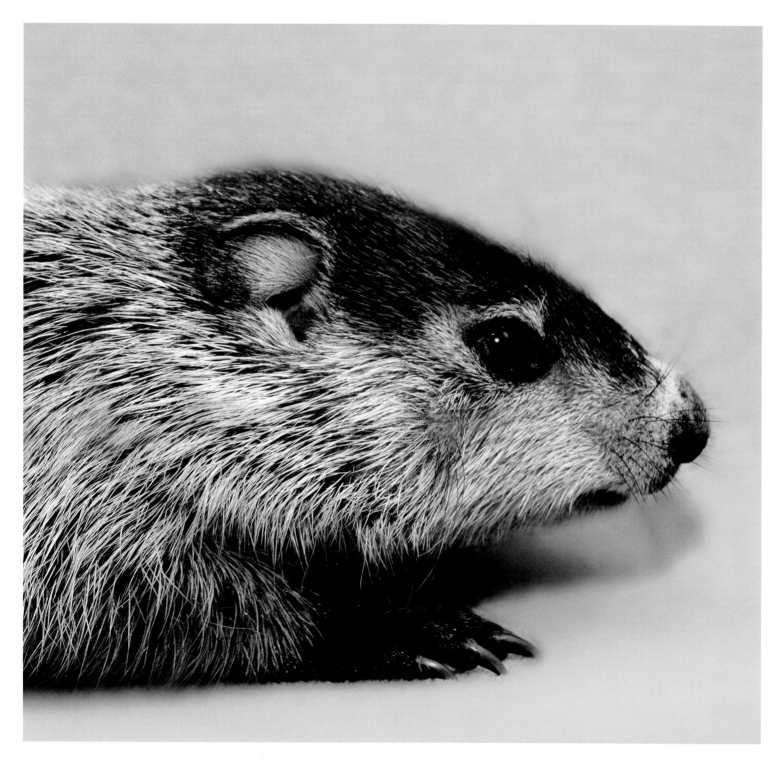

WEASEL

Six weeks old
Five days old

Weasels are solitary, territorial mammals. The only time weasels will come together is to mate. After a five-week gestation period, the female weasel will give birth to a litter of five to seven kittens that mature very rapidly. A young weasel is completely weaned and able to hunt small prey by the time it is two months old, and leaves its mother permanently a few weeks later.

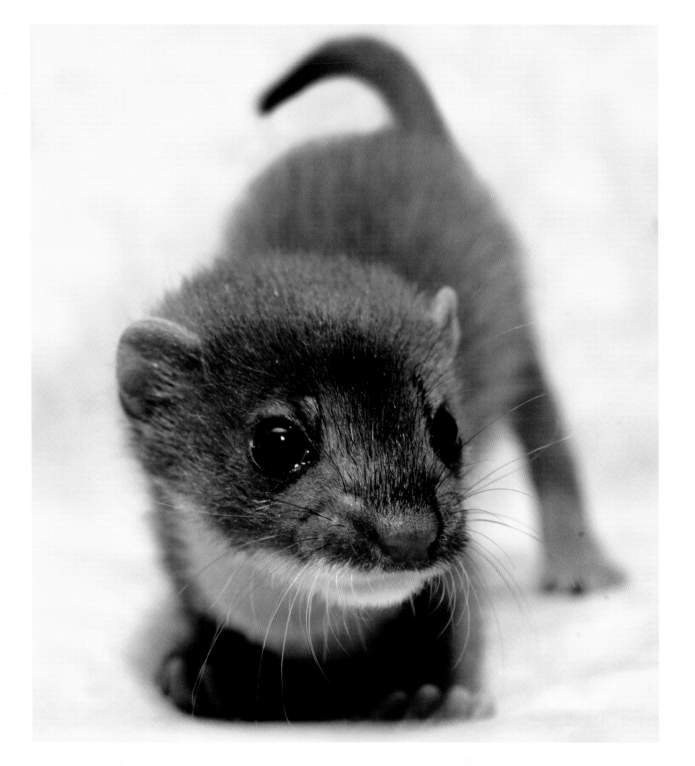

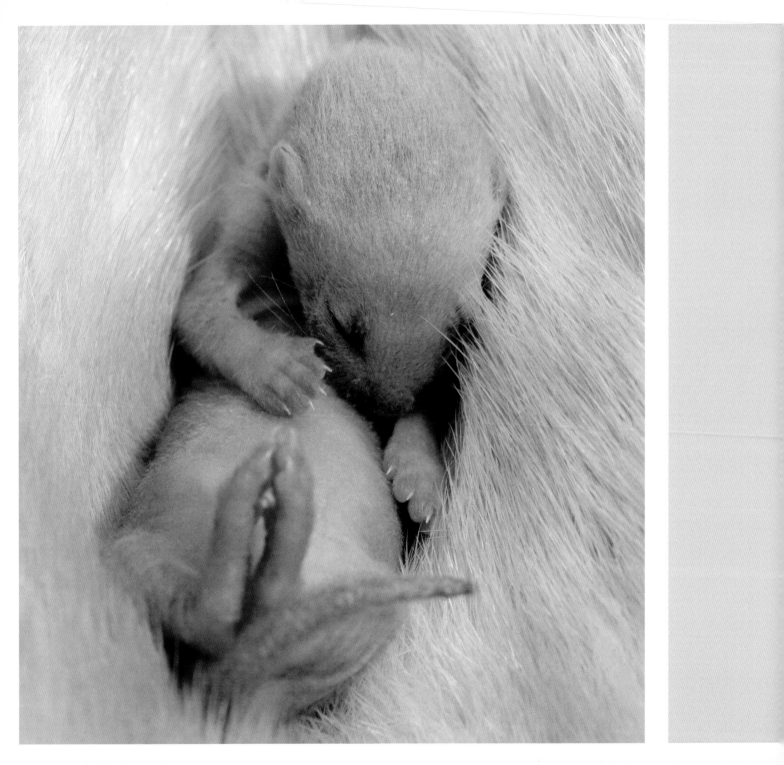

WHITE-FOOTED MOUSE

Two weeks old

A female field mouse is able to mate two to four times a year and, after a short gestation period, give birth to up to nine babies, which are blind, pink, and completely hairless at birth. These "pinkies," which are usually only a few centimeters long, will be completely weaned and able to leave the nest just twenty-one days after birth, and females can have their first litter at the age of thirteen weeks.

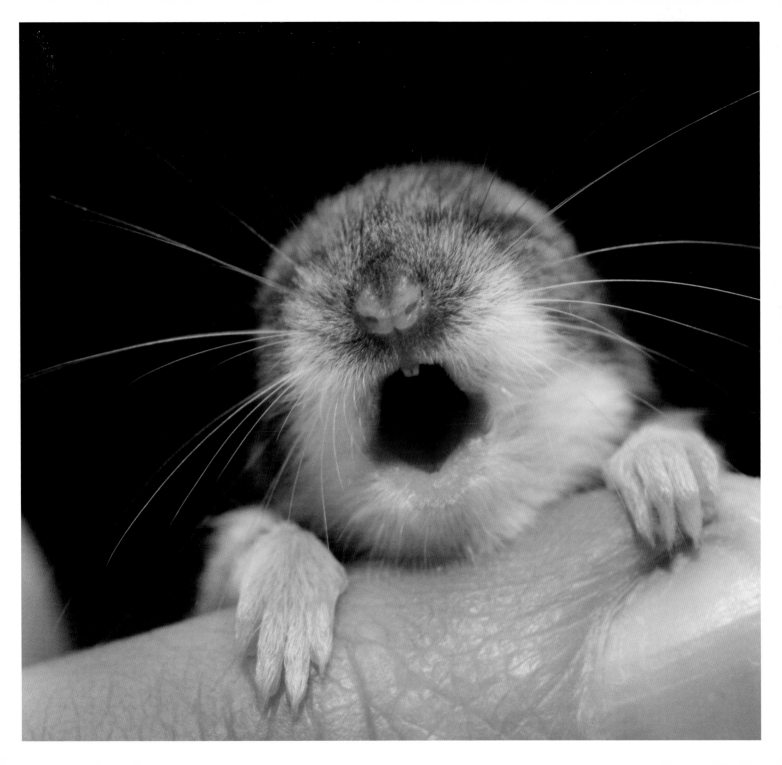

WOOD DUCKLING

Five weeks old
Three weeks old

Wood duck hatchlings are famous for the death-defying
stunt that they all must perform very early in life. Wood
ducks make their nests high in trees and just one day
after hatching, before they are able to fly, the newborn
ducklings must follow their mother's voice and leap
out of the nest, falling up to fifty feet onto the leaf litter
below. They then line up and follow their mother to
water, where they take their first swim.

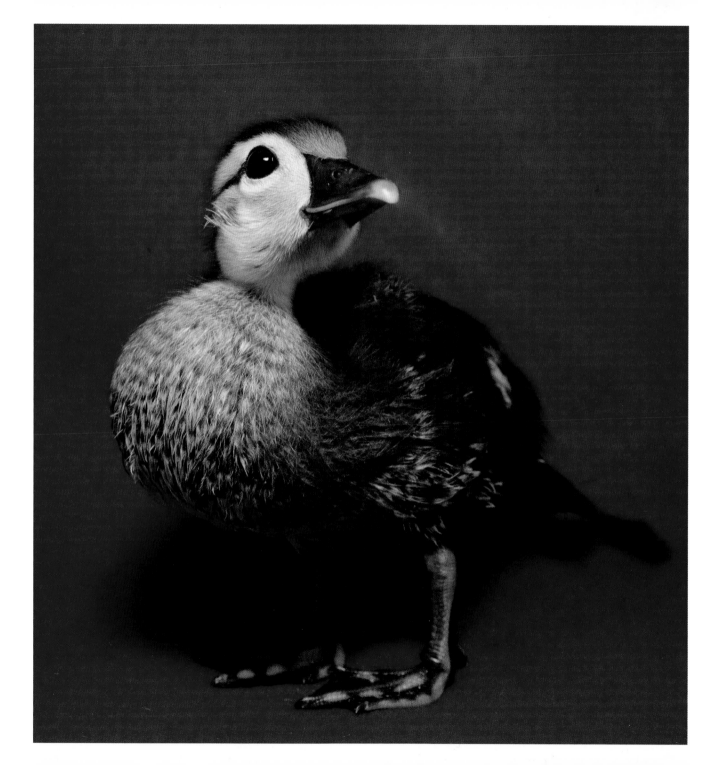

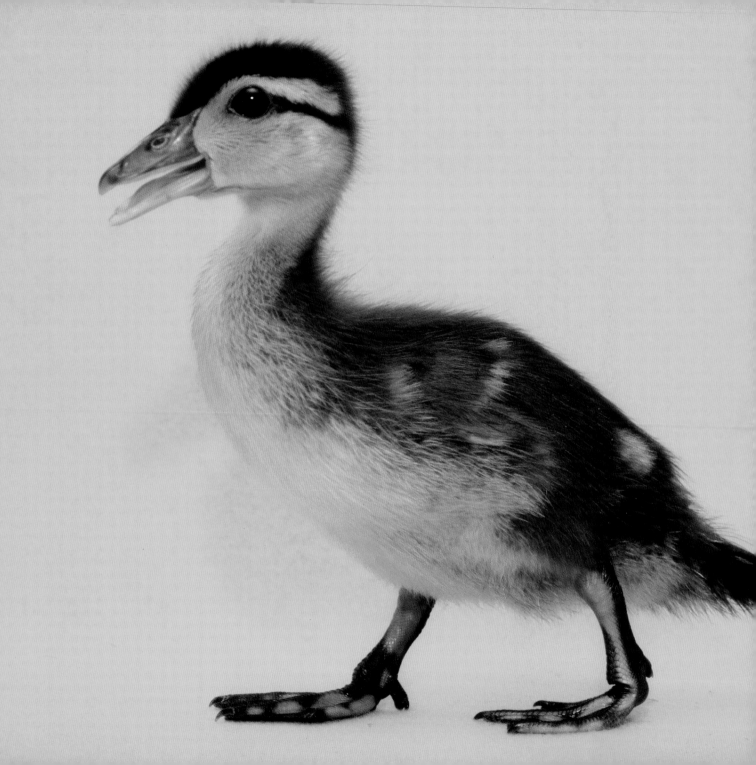

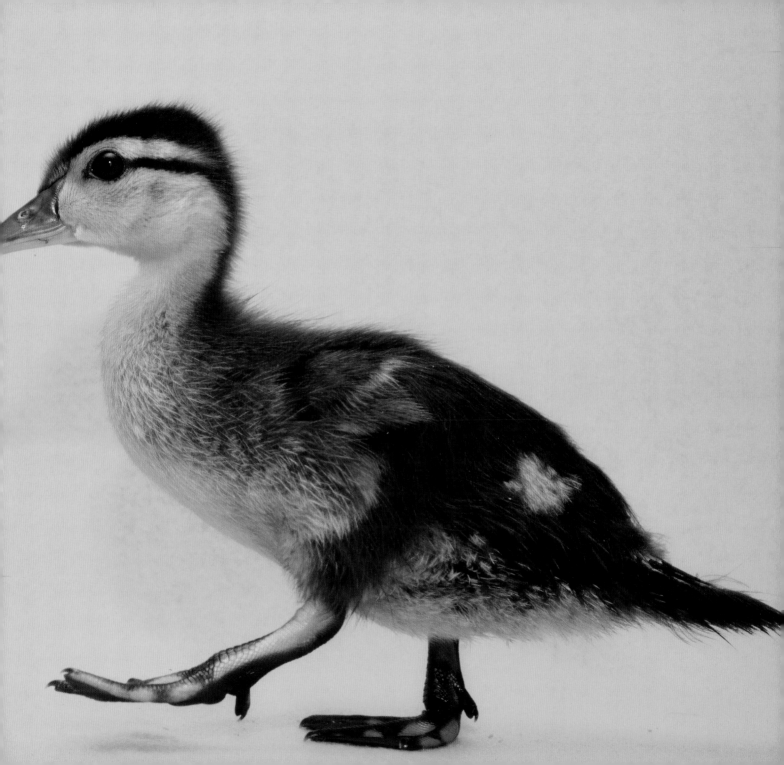

OSPREY

Three weeks old

The osprey is a bird of prey that feeds exclusively on fish and is found on all continents except Antarctica. Ospreys mate for life, and both the mother and father participate in raising the chicks. Osprey nests are enormous piles of sticks, driftwood, and other debris that are usually built on top of man-made structures like telephone poles or duck blinds. The female lays two to four eggs, and chicks will often hatch several days apart. If food is scarce, the chicks that hatch first will be the ones to survive.

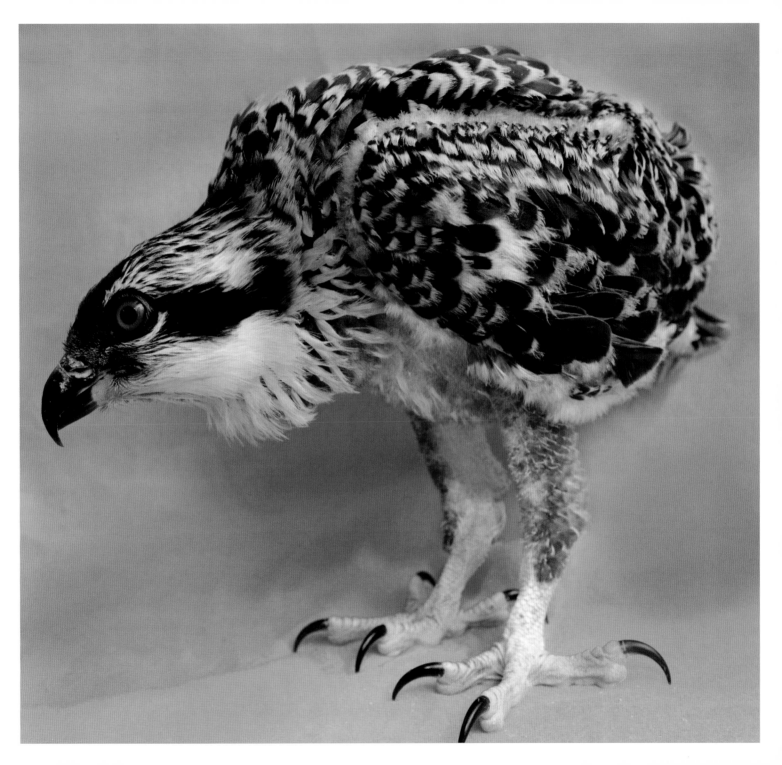

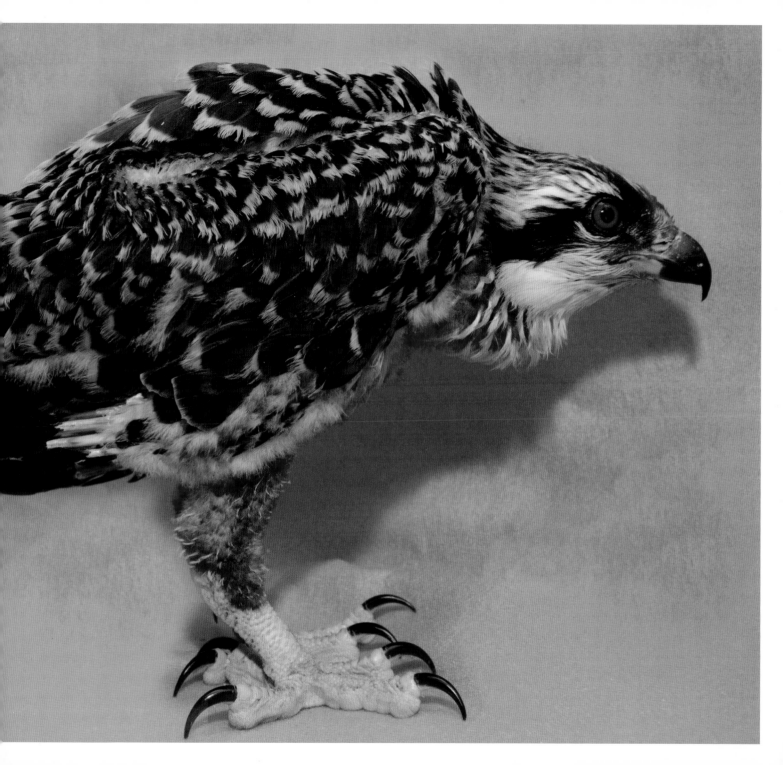

RING-NECKED PHEASANT

Five weeks old

Pheasant chicks are capable of brief flights by the time they are only two weeks old. For the next six weeks, they stay with their mother hen, who provides protection from the weather and from potential predators. Soon after, chicks will leave the nest and strike out on their own.

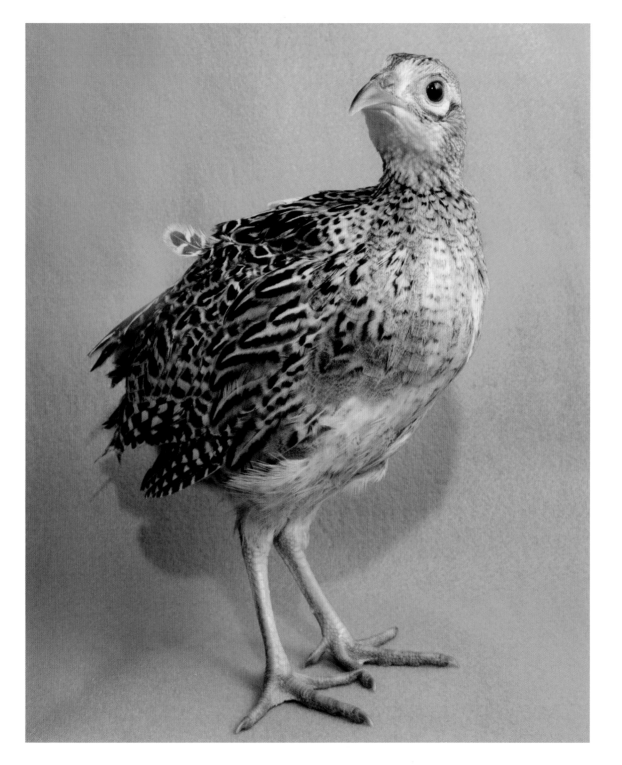

ROBIN

Four weeks old

The American robin is one of the most abundant species of bird in America, and is the state bird of Connecticut, Michigan, and Wisconsin. A female robin will lay a clutch of three to five pale blue eggs that hatch after about fourteen days of incubation. Chicks are born featherless, with sealed eyes, and require constant care by the mother for the first few days until they are able to regulate their body temperature. After just fourteen to sixteen days, the baby birds are ready to leave the nest, or fledge, for the first time. Fledging robins will stay close to their parents for up to three weeks, during which time the parents will continue to feed them. This fledgling robin at four weeks can walk and hop, and is just beginning to learn how to fly.

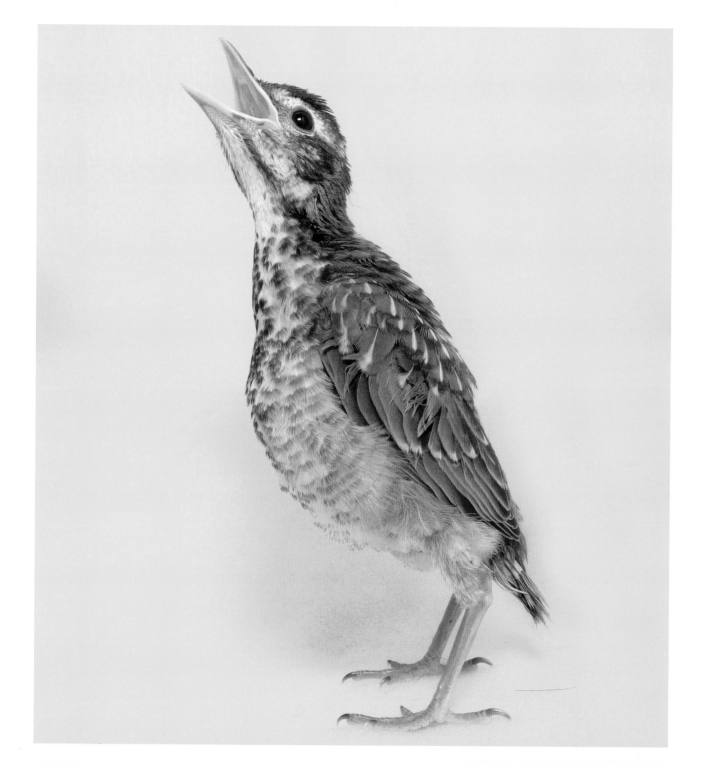

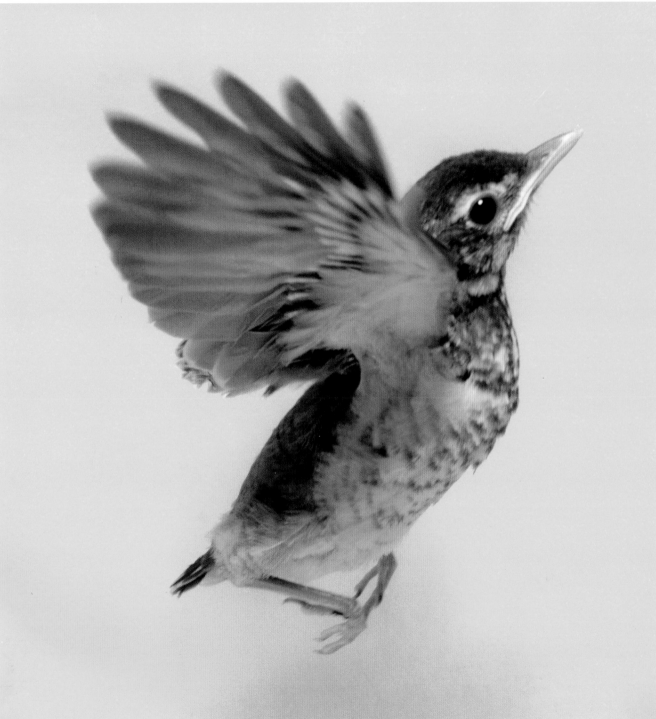

WHITE-TAILED DEER

Six weeks old

A newborn fawn can stand within a half hour of its birth, and usually takes its first steps within a few hours. By the time a fawn is three weeks old it can outrun most predators. A mother deer will leave her fawn in thick cover while she forages nearby, usually staying within a hundred yards. By staying near but not right next to the fawn, she is able to keep an eye on the baby while not attracting predators to it.

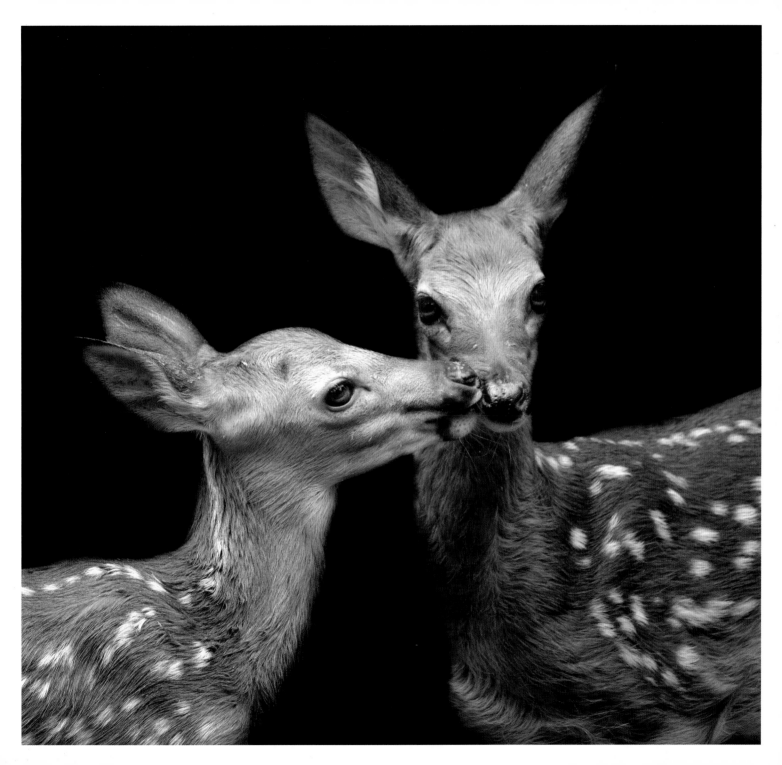

COATI

One month old

Coati, or coatimundi, are members of the raccoon family, found primarily in Central and South America. They are omnivores whose diets consist mainly of what they find on the ground. Fruit, bird eggs, and even tarantulas are staples of the coati diet. Baby coatis are called kits.

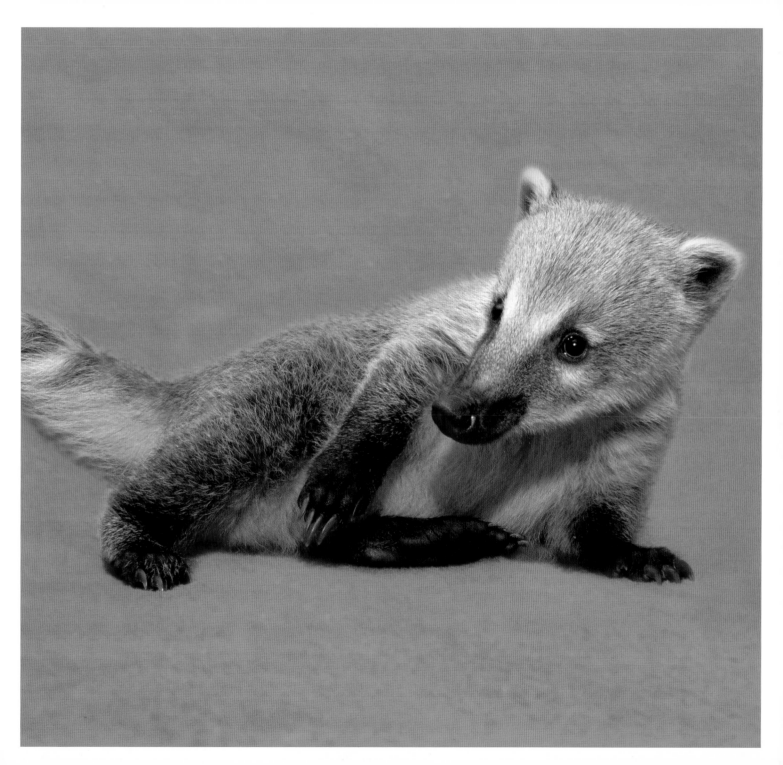

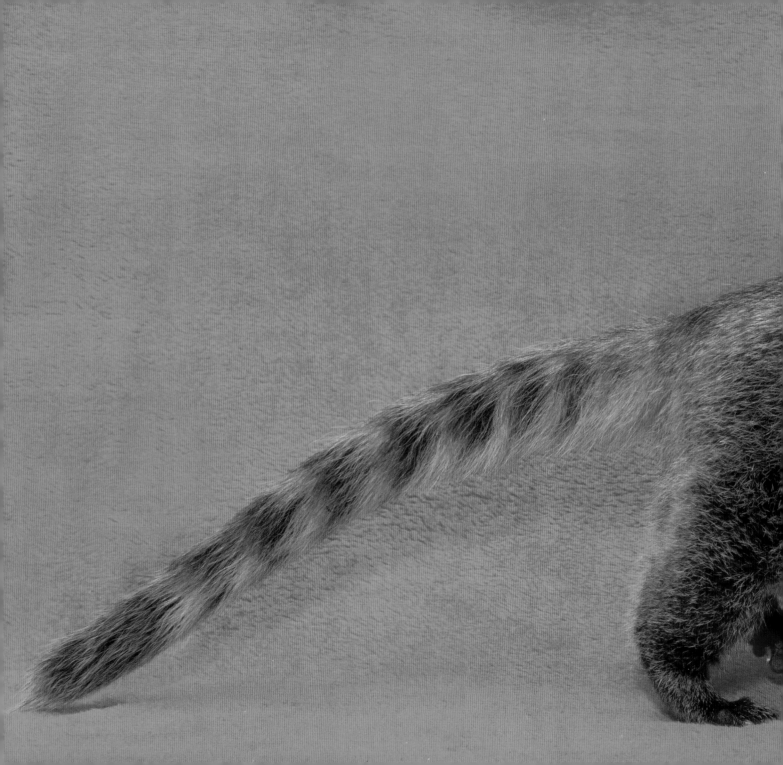

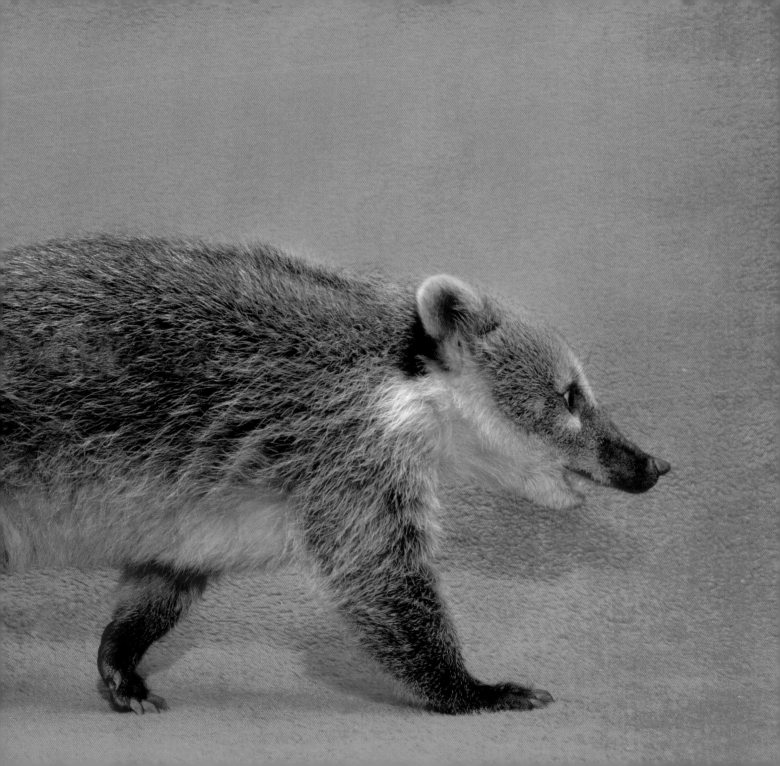

PIGEON

*One to
two weeks old*

Although most people have never seen a baby pigeon,
or squab, they are in fact very plentiful. Pigeons tend
to build their nests very high up in urban structures
that mimic cliffs—places like rooftops and ledges—
and under bridges. Squabs stay in the nest for up to six
weeks, at which point they are full-grown, and so by
the time they emerge, it is difficult to tell them apart
from their parents.

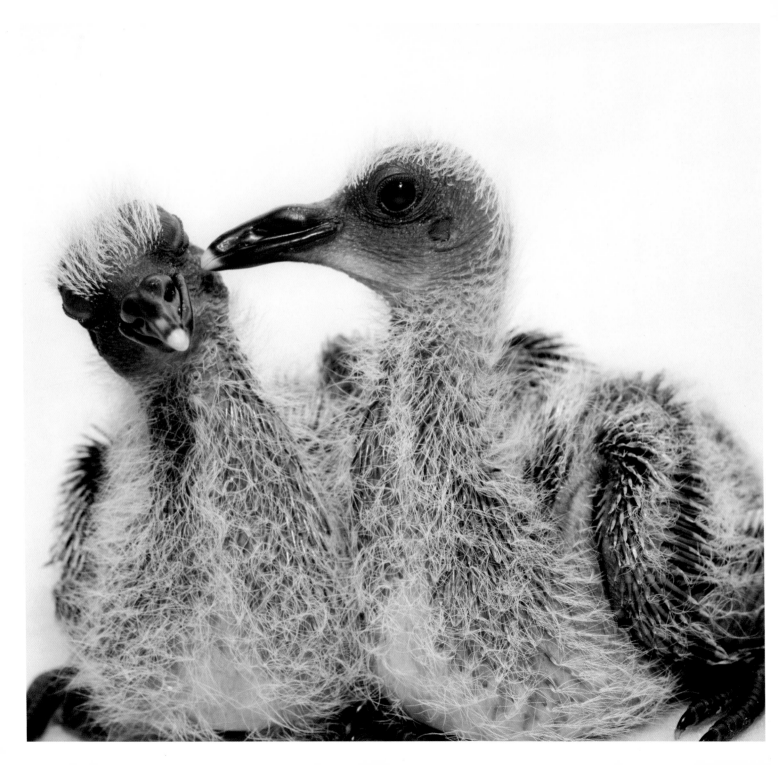

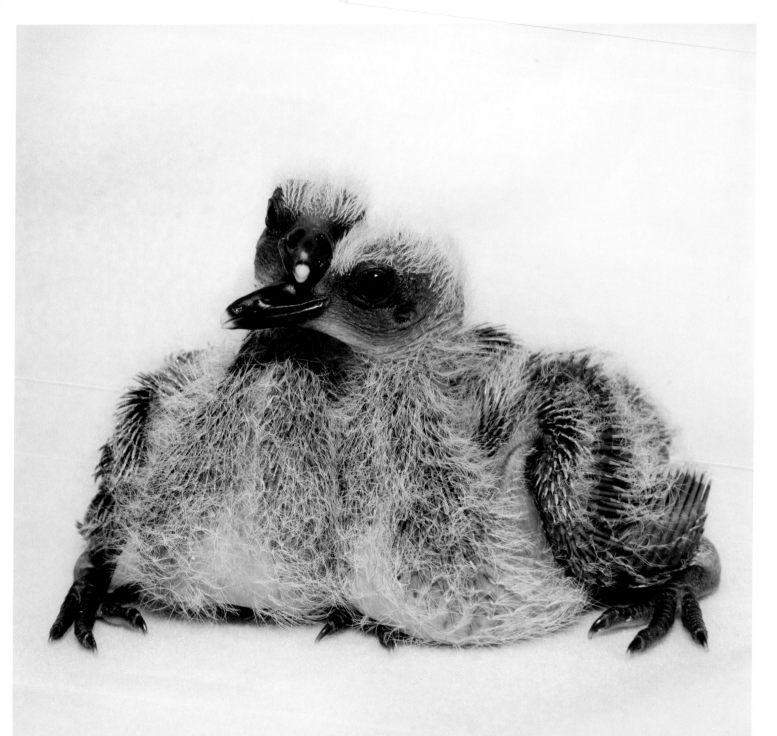

CALIFORNIA SEA LION

Ten months old

Sea lion pups are born on land and nursed by their mothers for about six months. They learn to swim at two or three months, and then slowly begin learning to hunt with their mothers. Unlike many mammals, they can see and walk immediately after birth. A pup can recognize its mother's unique bark amidst a crowd of hundreds of other sea lions.

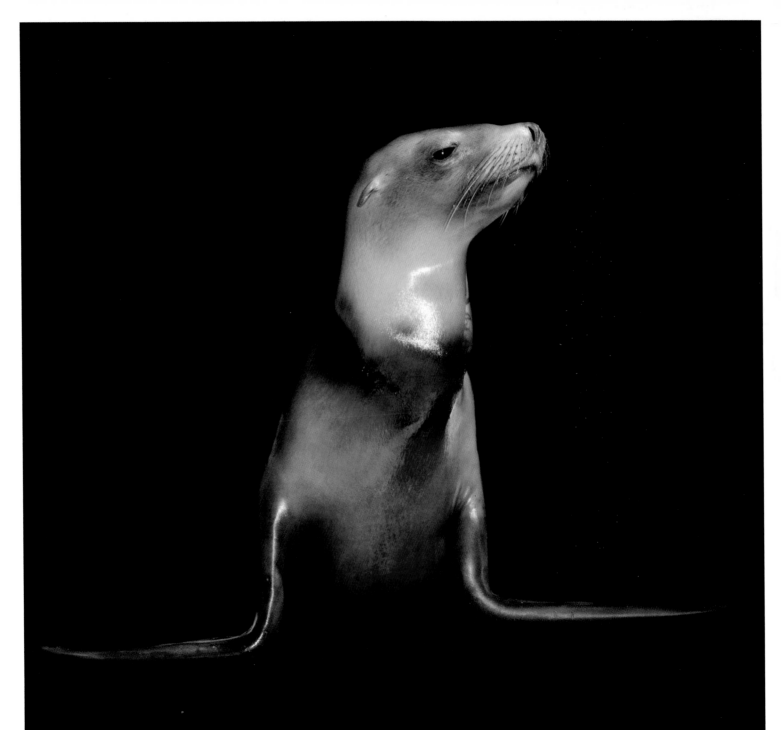

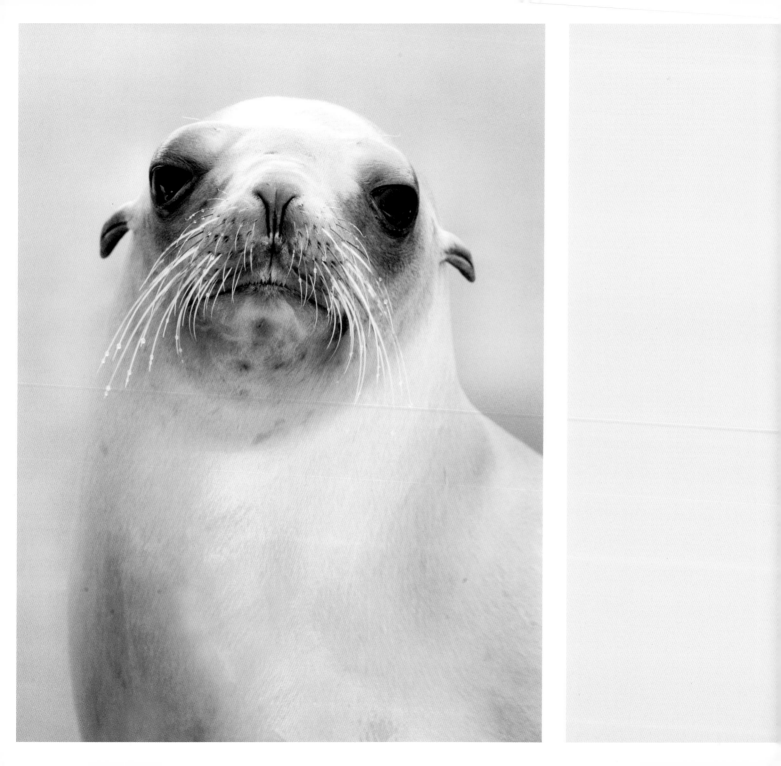

RUBY-THROATED HUMMINGBIRD

Nine months old

This juvenile female ruby-throated hummingbird will not develop the distinctive red throat of her adult male counterparts. Young hummingbirds take their first flight at eighteen to twenty-two days old, and will live a solitary life, coming together only to mate.

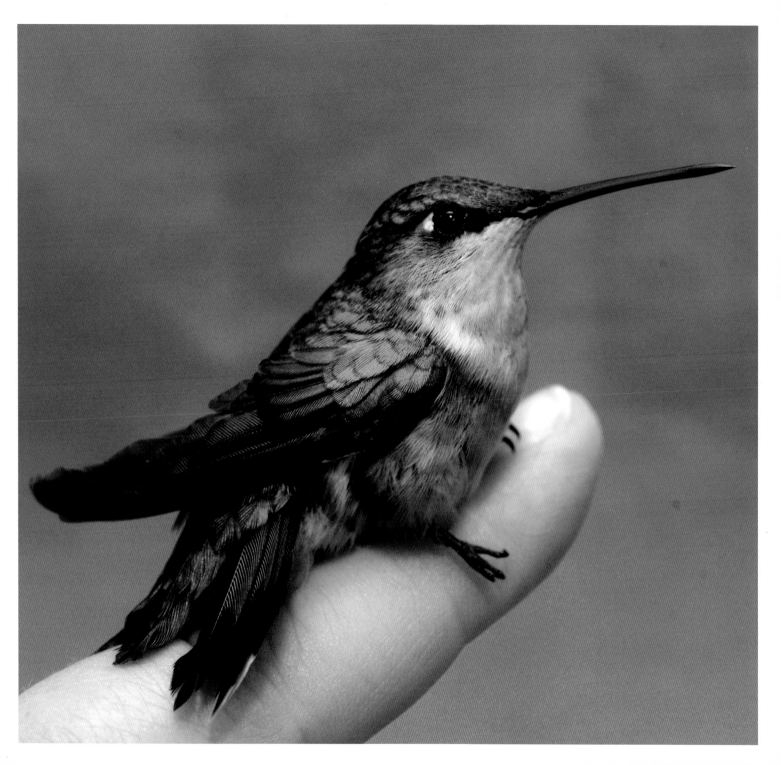